Bright Lights, Dark Nights

GREAT LAKES LIGHTHOUSES

Bright Lights, Dark Nights

GREAT LAKES LIGHTHOUSES

LARRY & PATRICIA WRIGHT

The BOSTON
MILLS PRESS

Dedicated to our children, Jarret and Kelly,
who keep us young.

CATALOGING IN PUBLICATION DATA

Wright, Larry, 1949–
Bright lights, dark nights: Great Lakes lighthouses

ISBN 1-55046-312-8

1. Lighthouses – Great Lakes – Pictorial works.
2. Lighthouses – Great Lakes – History.
I. Wright, Patricia, 1949– . II. Title.

VK1023.3.W753 1999 387.1'55'0977 99-930159-4

03 02 01 00 99 1 2 3 4 5 6

First published in 1999 by
BOSTON MILLS PRESS
132 Main Street
Erin, Ontario N0B 1T0
Tel 519-833-2407
Fax 519-833-2195
e-mail books@boston-mills.on.ca
www.boston-mills.on.ca

An affiliate of
STODDART PUBLISHING CO. LIMITED
34 Lesmill Road
Toronto, Ontario, Canada
M3B 2T6
Tel 416-445-3333
Fax 416-445-5967
e-mail gdsinc@genpub.com

Distributed in Canada by
General Distribution Services Limited
325 Humber College Boulevard
Toronto, Canada M9W 7C3
Orders 1-800-387-0141 Ontario & Quebec
Orders 1-800-387-0172 NW Ontario & Other Provinces
e-mail customer.service@ccmailgw.genpub.com
EDI Canadian Telebook S1150391

Distributed in the United States by
General Distribution Services Inc.
85 River Rock Drive, Suite 202
Buffalo, New York 14207-2170
Toll-free 1-800-805-1083
Toll-free fax 1-800-481-6207
e-mail gdsinc@genpub.com
www.genpub.com
PUBNET 6307949

We acknowledge for their financial support of our publishing program the Government of Canada
through the Book Publishing Industry Development Program (BPIDP),
the Canada Council, and the Ontario Arts Council.

Design by Gillian Stead
Printed in Hong Kong by Book Art Inc., Toronto

CONTENTS

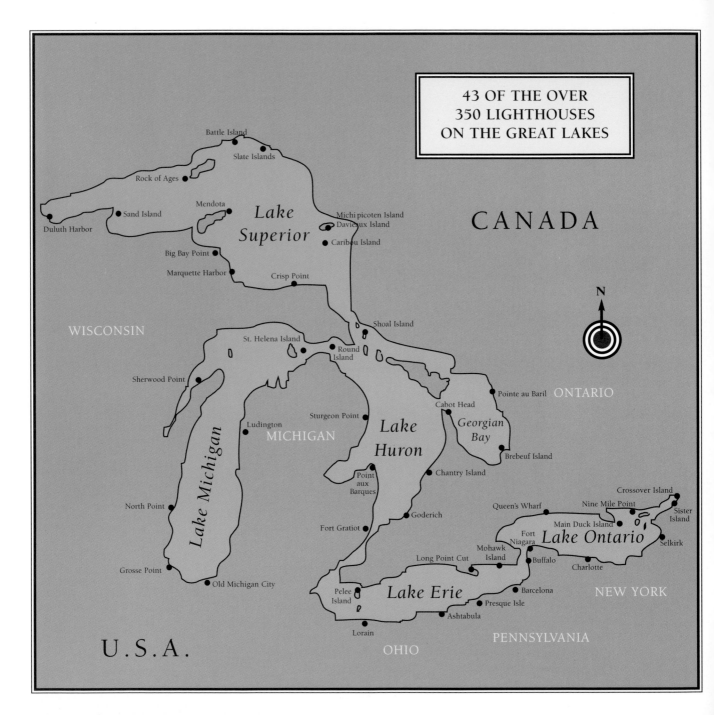

43 OF THE OVER
350 LIGHTHOUSES
ON THE GREAT LAKES

CANADA

N

Battle Island
Slate Islands
Rock of Ages
Mendota
Michi picoten Island
Davieaux Island
Sand Island
Duluth Harbor
Caribou Island
Big Bay Point
Marquette Harbor
Crisp Point
Lake Superior

WISCONSIN

Shoal Island

St. Helena Island
Round Island
Sherwood Point
Pointe au Baril
ONTARIO

Sturgeon Point
Cabot Head
Georgian Bay
Ludington
MICHIGAN
Lake Huron
Brebeuf Island
Lake Michigan
Point aux Barques
Chantry Island
North Point
Goderich
Fort Gratiot
Crossover Island
Queen's Wharf
Nine Mile Point
Sister Island
Main Duck Island
Fort Niagara
Lake Ontario
Selkirk
Grosse Point
Long Point Cut
Mohawk Island
Buffalo
Charlotte
Old Michigan City
Pelee Island
Lake Erie
Barcelona
NEW YORK
Presque Isle
Ashtabula
PENNSYLVANIA
Lorain
U.S.A.
OHIO

INTRODUCTION

"So to night-wandering sailors pale with fear
Wide o'er the watery waste a light appears,
Which on the far-seen mountain blazing high
Streams from lonely watchtower to the sky."

Homer, *The Iliad*, 750 BC

During early settlement of the uncharted North American wilderness, water was the easiest and fastest mode of transportation. Settlements developed around the St. Lawrence River and the Great Lakes, but swift currents, shoals, reefs, shifting sand bars, fierce, fast-approaching storms and narrow, uncharted passages with no navigational aids made travel a mariner's nightmare. Seasoned captains relied on memory, instinct, and poor maps and charts. By the 1850s, schooners, propellers, steamers, brigs, barques and sloops plied the Great Lakes. To maximize profits, many companies operated poorly built and poorly maintained steam vessels at night, and this increased collisions, fires, and grounding incidents. Simple lanterns on poles were used to mark harbors. Lighthouses were built only after pressure was brought to bear on the government of the day.

There are four classifications of lighthouses, based on function: landfall lights, major coastal lights, secondary lights and harbor lights. The height of a light above the water and the size of its lighting apparatus determine its range. Landfall lights, the highest and the brightest, are used for seagoing vessels. Great Lakes lights usually fall into the three smallest classes: harbor lights, coastal lights, and secondary lights.

Early lighthouses were stone towers that used catoptric reflectors with oil-burning lamps. These lighthouses employed a birdcage lantern with polygonal sides, each with many small panes of glass held in place by metal frames called astragals. To support the lantern, these metal bars curved up, over, and around the lantern. In the 1850s Fresnel lenses were installed in the lanterns. However, the metal bars of the birdcage-style housing interrupted the focal plane of these new lenses, so the lantern was changed to use larger round or polygonal panes of glass and no metal support bars. Selkirk is one of the few remaining lighthouses with a birdcage lantern.

Most Canadian lighthouses had only one keeper. If assistants were required, they lived with the chief keeper and his family, sometimes even paying room and board. Canadian keepers were poorly paid, poorly trained, and had few instructions to guide them. Some even paid half their assistant's salary. Most keepers operated their lighthouses only during the navigational season, from spring thaw in late March to freeze-up in mid-December. The opening of the St. Lawrence Seaway to ocean-going vessels in 1959 sounded the death knell for many lighthouses. Huge sea-going vessels with depth gauges and modern satellite navigational systems, could travel from the Atlantic Ocean to the western end of

Lake Superior with no need for a lighthouse. In 1991 the last manned Canadian lighthouse on the Great Lakes, at Battle Island on Lake Superior, was automated and left without a keeper.

American lighthouses were built and maintained by the U.S. government, with the Lighthouse Board established in 1850. During the early twentieth century, many were automated and upgraded to use acetylene gas as a fuel. Automation and electricity in the 1920s led to the "demanning" of many U.S. lighthouses. Now under the control of the U.S. Coast Guard, the Lighthouse Board plans to eliminate all Great Lakes lighthouses by 2005.

But a century ago, being a lighthouse keeper was a unique occupation. The American Lighthouse Board sought a man between eighteen and fifty years old. Qualifiers were literate, could keep accounts, do hard labor and knew small boats. A family man was preferable, especially if he had mechanical aptitude and had served as a sea captain or mate. Canadians looked for a man between nineteen and forty years old with a good reference from his last employer, a certificate of good health, who could operate a boat, read, write, knew his arithmetic, and had good moral character. A family man was preferred because he could he manage longer in an isolated location, and his family provided free labor.

Both the American and Canadian keepers were federal employees, and occasionally were political appointments. In 1884 the American Lighthouse Board created uniforms — coat, vest, trousers, and hat — of indigo-blue jersey or flannel. Canadian keepers had no uniform. All keepers were supposed to be on call twenty-four hours a day. Because of low wages many lighthouse keepers had extra jobs. Government supply ships took American keepers to their lighthouses. But until 1920, Canadian keepers were expected to travel on their own in spring and winter on a government-issued sailboat, even if their lighthouse was 60 miles (96 km) out in the lake!

Unlike in Canada, U.S. lighthouse inspectors checked their stations for efficiency and cleanliness. The most proficient lighthouse received a flag of merit. Drunkenness and letting the light go out were both cause for dismissal. American keepers received supplies twice a year, including fuel, food, and books, along with feather dusters, rouge for polish, and spirits to clean away grease and oil. Canadians had to provide their own food supplies but were given ample soft linens and chamois for wiping and polishing lenses. The endless polishing and cleaning inspired at least one anonymous lighthouse rhyme:

On Brasswork

Oh what is the bane of a lightkeeper's life,
That causes him worry and struggle and strife,
That makes him cuss words and beat up his wife?
It's brasswork.

The lamp in the tower, reflector and shade,
The tools and accessories pass in parade,
As a matter of fact the whole outfit is made,
Of brasswork.

I dig, scrub and polish, and work with a might,
And just when I get it all shining and bright,
In comes the fog like a thief in the night.
Goodbye brasswork!

And when I have polished until I am cold,
And I'm taken a loft to the heavenly fold,
Will my harp and my crown be made of pure gold?
No brasswork!

The chores never ceased. A typical day might include tending the light, washing windows, cleaning the lens, and whitewashing the walls with concoctions of unslaked lime, salt, rice, whiting, glue, and boiling water. They used sand to filter impure or contaminated oil for lighthouse and house lamps. They continually trimmed the wicks to prevent the lamps from smoking. Revolving lenses required checking their mercury levels to float their ball bearings, and rewinding a clockwork mechanism of chains and heavy weights every two to four hours.

In lonely locations lightkeepers read, corresponded, built models, hunted, socialized, played cards, collected rocks or learned taxidermy. Wives canned, knitted, crocheted, sewed, or gardened. Children swam, picked wild berries, hunted, fished, and played games such as jacks, Parcheesi, pick-up sticks and croquet.

Today's lighthouses are almost lost to history. Canadian lighthouses have been automated and decommissioned. Lighthouses have been burned, blown up, or torn down to prevent costly maintenance, vandalism, and liability. Only recent public outcry has made people aware of their heritage and the need to preserve these irreplaceable structures. American lighthouses are now sold to local communities, who lease or sell them to historical societies, state park services, or private organizations or owners. At least two American lighthouses are bed and breakfasts. One American and one Canadian lighthouse can be privately rented (Selkirk and Salmon Point). Perhaps Canadians might follow the example of the United States Park Service: Their volunteer replacement program allows people to stay at a lighthouse for a summer in return for caretaking.

"Lighthouses are to America what castles are to Europe," a wise man said. These structures serve as monuments to a bygone era. Modern technology has rendered them obsolete and unwanted, but they have earned the right to be preserved as a part of our heritage and the right to grace our landscape for future generations.

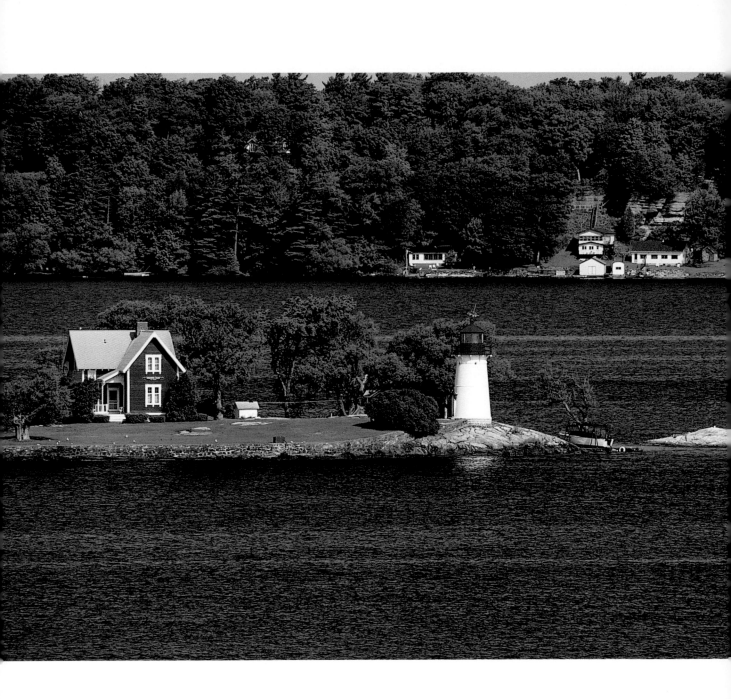

Crossover Island

Crossover Island lighthouse is a short, white structure on Crossover Island, one of the Thousand Islands in the St. Lawrence River, near Oak Point, New York. (Vessels crossed over from the American side to the Canadian Channel at this point.) Built of wood in 1848, the lighthouse was rebuilt in 1882 of steel and was painted white with a red lantern that housed a sixth-order Fresnel lens. Whale-oil lamps were followed by kerosene and finally battery power. The island complex consists of the keeper's house, the lighthouse tower, a well, a hen house, a barn, a privy, an oil house, and a smokehouse.

Ralph Hill and his six siblings grew up on Crossover Island. His father was keeper here from 1909 until 1931, during which time he rescued hundreds of stranded mariners, including the occupants of a crashed biplane. Each weekday Ralph's father rowed his children three-quarters of a mile (1.2 km) across the channel to attend a one-room schoolhouse. The government supply boat, the S. S. *Crocus*, brought supplies twice a year, including coal, kerosene oil, soap, paint, flour, lard, and library books. The Hill family supplemented the government supplies with produce from their small garden. They also raised chickens and pigs. During June nights, they speared hundreds of eels when the eels surfaced to feed on eel flies. The eels were smoked and sold as hors d'oeuvres for winter parties. A frugal housekeeper, Mrs. Hill recycled cloth flour sacks to make undergarments for the family, canned saurkraut, pickles, carrots and beets, strained and saved bacon and chicken grease for later cooking, and earned extra money in summer by doing laundry for cottagers.

At the end of the navigational season the family moved to Ogdensburg, where the family reveled in the modern conveniences of running water, indoor plumbing and electric lights.

The lighthouse was decommissioned in April 1941. Today it is a privately owned cottage.

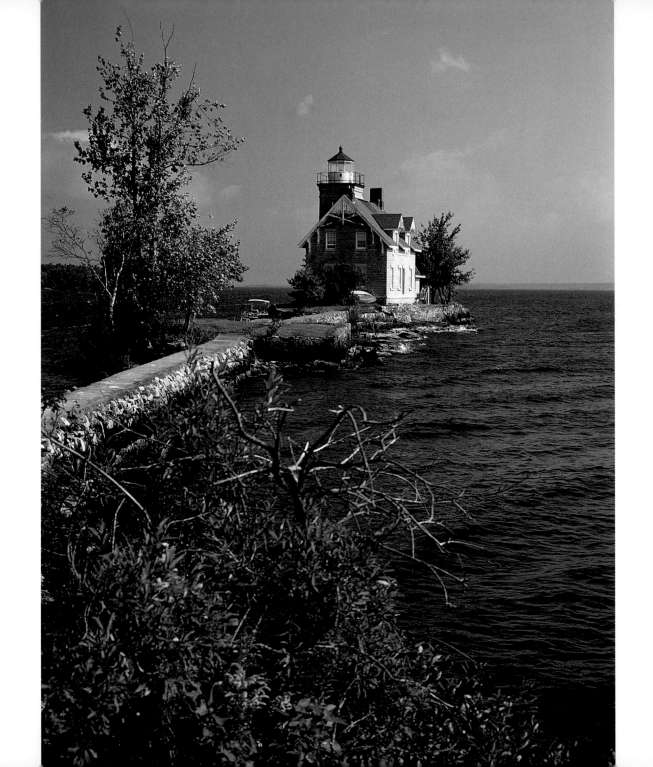

Sister Island

NEW YORK

Sister Island, located in the St. Lawrence River near Lake Ontario, is actually three small islands joined by a stone-and-concrete walkway. A lighthouse was built in 1870 to mark a tricky channel on the Canadian side of the island. When the lighthouse was commissioned, the river channel was moved to the American side of the island. Divers worked from a river barge, placing explosives in holes drilled in the riverbed. Before work was completed, nine crew members lost their lives when the barge was struck by lightning and blown up during a summer thunderstorm.

The castlelike two-story limestone house and tower with distinctive stone molding under its gallery has 18-inch-thick (46 cm) walls. The square tower is built into the center of the north side of the house and extends one-story higher than the rooftop. The gallery is surrounded by a black iron railing and topped with a dodecagonal lantern with a black dome and a brass ventilator ball. On the south side, two dormer windows add room and light to the upstairs bedrooms. The windows are quaint with their twelve small panes of glass and the gables of the house have ornate white braces under their eaves. The original house had a slate roof with black trim. Under the eaves and behind the wood trim are two narrow windows almost hidden from view, which provide light and ventilation to the attic, used by the current owner's children as a pirates' hideout.

An annual annoyance on Sister Island was the shad fly invasion, which came in such force that they covered the ground. The keeper had to be alert that the pests did not block the oxygen intake to the lantern. An extinguished flame could cause a dangerous gas leak within the tower.

The badly vandalized lighthouse was sold as surplus in 1963 by a sealed bid in New York City for less than $7,000 to Alfrieda and Edward Wolos, who restored it year by year into one of the most attractive lighthouses on the sweetwater route to the interior, with well-manicured lawns on all three islands, and charming limestone-and-wood architecture throughout.

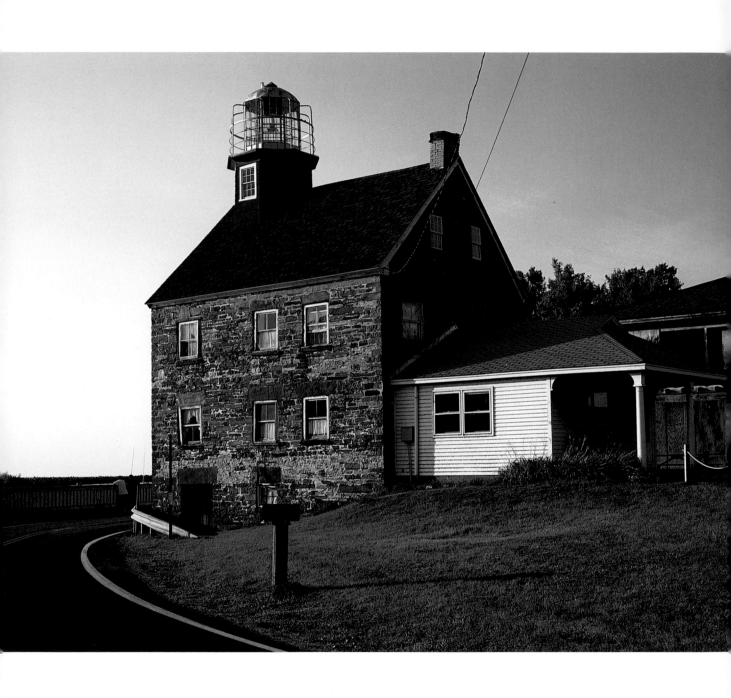

Selkirk Lighthouse

NEW YORK

Some claim the lighthouse at the mouth of the Salmon River was named after a rogue sailor named Alexander Selkirk, who inspired Daniel Dafoe's *Robinson Crusoe*. More likely, the island was named after Thomas Douglas, the Earl of Selkirk, who owned thousands of acres of land on the north side of the Salmon River at the beginning of the 1800s.

In the 1830s a government engineer determined that the harbor could safely anchor thirty ships, and a lighthouse was built in 1838 to mark the entrance to the harbor. The lighthouse was originally called the Salmon Point River Light Station. Local contractors Joseph Gibbs and Abner French were awarded the contract, at a cost of $3,000. They hired Jabez Meacham, a local stonemason, who did most of the actual work. Topped by a wooden platform on which a birdcage lantern sits, the octagonal lantern, with its fifteen small glass panes on each side, has a 14-mile (23 km) visibility.

The keepers were paid $350 annually. After each navigation season they returned to their homes in Pulaski/Richland for the winter.

In 1895 the lighthouse was sold by auction as government surplus to Leopold Joh, a German immigrant and successful hotelier from Syracuse, who built the prestigious Lighthouse Hotel. After Leopold's death the Heckle family purchased it, doubled its size and made it famous for German cuisine. During Prohibition it was popular with smugglers.

In 1976, the American bicentennial year, the Oswego Heritage Foundation declared the lighthouse a Designated Historic Landmark. Since 1987 Jim Walker has worked diligently on its restoration. On August 6, 1989, he re-lit the lamp as a private aid to navigation, and in 1994 he created a website to attract awareness and tourism from around the world. To raise funds, he rents out the lighthouse, one of only two live-in lighthouses on the Great Lakes, and the only one with a birdcage lantern.

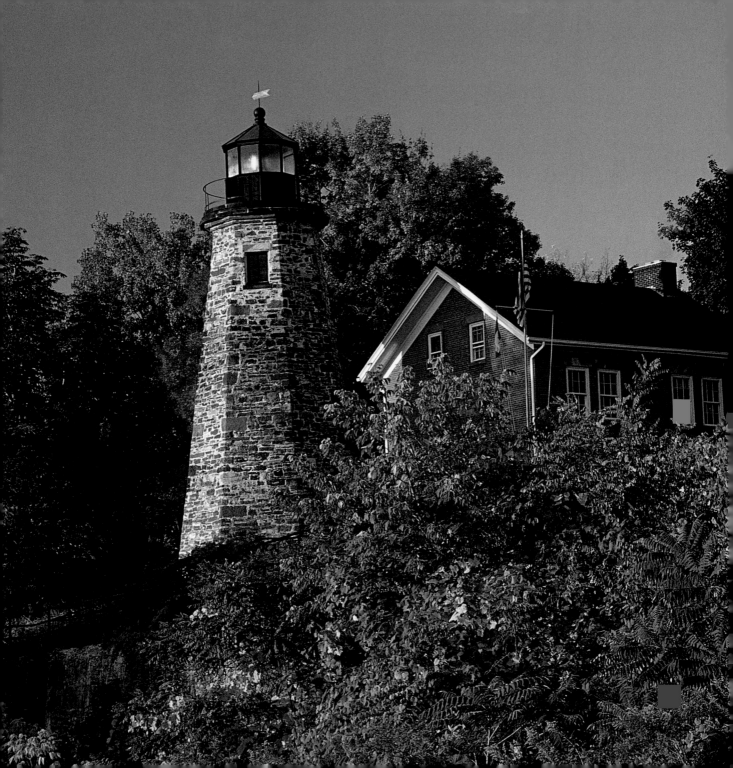

Charlotte / Genesee

NEW YORK

In 1820 Congress appropriated $5,000 to build a lighthouse at the mouth of the Genesee River to replace lanterns hung on pilot trees. On arrival, vessels would use steam whistles and ring bells until they were properly docked. A safer, less noisy entry was sought. In 1821 the government purchased acreage from Mrs. Mehitabel Hincher, the widow of the first settler, for $400. Ashbel Symonds was awarded the contract and completed the lighthouse by September 1822 for a cost of $3,300.

The octagonal limestone tower was built to last, with tapered walls from 4 feet (1.2 m) to 2 feet (.6 m) thick. The base of the octagonal tower was 22 feet (7 m) in diameter. The lantern's diameter was 11 feet (3.4 m) and the gallery's deck had a diameter of 13 feet (4 m). The original lantern was birdcage-style with eighteen small panes of glass in each of its octagonal sections, or 144 panes of glass. The four windows along the length of the tower each had four panes. The lantern was equipped with ten Winslow-Lewis lamps and reflectors and was fueled with whale oil.

In 1838 a secondary light was placed at the end of the west pier. In 1852 Congress appropriated $2,600 to rebuild the pier tower, install a new lens and build a catwalk to the pier tower for the keeper's safety during storms. They appropriated another $2,000 to renovate the lighthouse on the bluff. In 1853 the original wooden stairs were replaced by a cast-iron stairway. The lamps and reflectors were replaced by a fourth-order Fresnel lens. A new cast-iron deck and lantern with ten large panes of glass replaced the sashes and bars of the old birdcage-style lantern, which would have obstructed the new light.

In 1863 the government tore down the small keeper's house and used the stone for the foundation of the new two-and-a-half-story, red-brick keeper's house connected to the tower by a brick passageway. In 1881 this lighthouse was deactivated, though keepers continued to maintan the pier light.

In 1939 the United States Coast Guard absorbed the United States Lighthouse Service, and under its jurisdiction, by 1947 the light had been fully automated. From 1947 to 1982 the brick house was the residence for the local chief of the Coast Guard, who maintained the lighthouse.

In 1982 the Charlotte Community Association leased the two buildings as a heritage property and museum. Restoration began immediately. Archeologists discovered the original well and lightning rod. A fourth-order Fresnel lens was installed by the United States Coast Guard and the lamp was re-lit in June 1984 as part of the Rochester sesquicentennial celebrations.

In 1991 the deed passed over from the United States government to Monroe County. The Lighthouse Society has a twenty-year lease from the county to operate the premises as a museum.

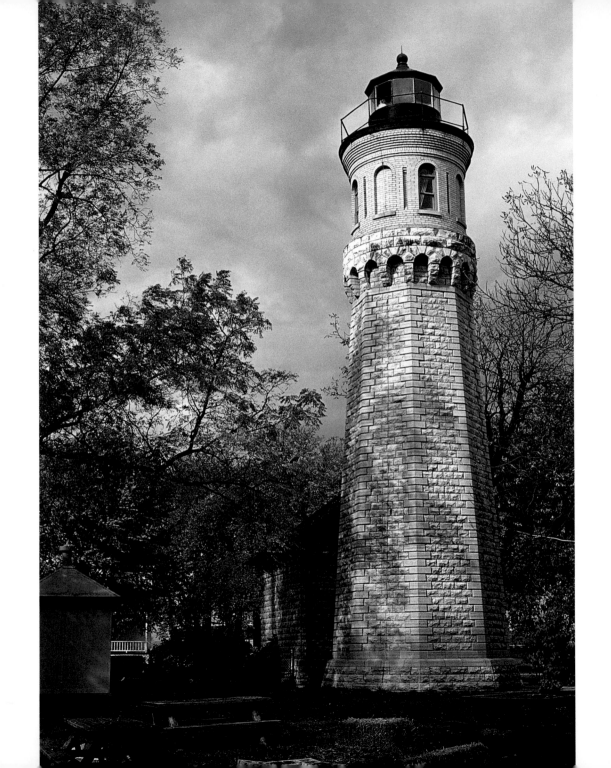

Fort Niagara

NEW YORK

During the eighteenth century, Fort Niagara's garrison at the mouth of the Niagara River and Lake Ontario probably used bonfires to guide vessels through the fog and darkness. In l782, late in the American Revolution, the British established a light at Fort Niagara, which was then called "the French Castle." Some considered this the first light on the Great Lakes. But it was not a true lighthouse. A cupola about 40 feet (12 m) above the parade ground was constructed on a pedestal on the roof of the Castle. This light remained in service until 1796 or later, but was removed by 1806.

In 1796 the British relinquished Fort Niagara to the United States They retired to the west side of the river and by 1800 built a new post, Fort George. British and American commerce increased, and by 1804 a true lighthouse had been constructed at the mouth of the Niagara River by British soldiers from Fort George. The Newark Lighthouse was a 40-foot (12 m) hexagonal stone tower built on Mississauga Point (presently the site of Niagara-on-the-Lake Golf Course), directly opposite Fort Niagara. This light survived the War of 1812, as both the British and the Americans valued its service. Then, in 1814, the British demolished it to clear a site for construction of Fort Mississauga. The Niagara River remained unlit for the next nine years.

In the years following the War of 1812, steamboats replaced sailing vessels. In 1823 a squat octagonal pedestal was erected on the messhouse roof at the Castle at Fort Niagara to support a lamp and mark the mouth of the Niagara River. A regularly assigned lightkeeper made his home at the current site of the Coast Guard station, where he also operated a ferry and a tavern.

A third lighthouse was finished in 1872 on the American side at the mouth of the Niagara River. Built on the riverbank just south of the fort, it was a 45-foot (14 m) stone tower. With a yellow-brick extension built in 1900, it now has a 56-foot (17 m) tower. The lighthouse stands 91 feet (28 m) above water level. The sixty iron steps of its spiral staircase lead to the decagonal lantern.

The lighthouse was automated in 1983, the same year the Old Fort Niagara Association received permission to use the lower part of the lighthouse as an exhibit, information center and gift shop. In 1993 the light was decommissioned. Today the lighthouse is part of Fort Niagara State Park and is easily accessible from April to Labor Day.

Queen's Wharf

ONTARIO

I n the nineteenth century, Lake Ontario reached as far north as historic Fort York. Until a storm in 1853, Toronto Island was connected to the mainland and called Gibraltar Point. Queen's Wharf was built in 1834-1837 on the west side of the western gap into Toronto Harbor. The wharf was located just southeast of the fort, near the foot of Bathurst Street. Sandbars made navigation into the harbor tricky. At first an oil lantern was erected as a pier light at the end of the wharf. In 1838-1839 a small one-story lighthouse was erected.

In 1854 the Harbor Trust established a system of range lights — one red, the other white — on the Queen's Wharf. In 1855 the iron lantern for the Queen's Wharf lighthouse was built. In 1859 the lights were converted to kerosene from sperm whale oil. Finally, in 1861, the structure for the Queen's Wharf lighthouse was built and its lantern moved from the storehouse to the new wooden structure. In 1867 a new white range light was erected.

The Queen's Wharf lighthouse took its name from the wharf where it was situated. Considered a harbor light as well as a range light, it was painted red, was relatively short, about 24 1/2 feet (7.5 m), and its red light was visible for approximately 6 nautical miles (11 km) in clear weather. It was coupled with a white range light and fog bell. Vessels maneuvered until the red light lined up behind the white light, then the captain steered through the deepest water of the harbor entrance to avoid the sandbar.

In 1880 locomotive light equipment was installed into these range lights. In 1881 pipes supplied the lights with natural gas. They used an open flame instead of a wick until mantles were installed. In 1885 the Queen's Wharf lighthouse was moved north onto a new crib to improve its range. Between 1908 and 1912 a new, deeper western channel into the harbor was constructed. New lighthouses were built to mark the new channel, and the Queen's Wharf light was taken out of service in 1911. In 1929, after harbor improvements landlocked the old Queen's Wharf lighthouse, it was dragged southwest by a team of horses over wooden rollers to its present location at the junction of Fleet Street and Lakeshore Boulevard.

In 1961 the Toronto Harbor Board received jurisdiction of the lighthouse. Today, surrounded by tall buildings and a streetcar turnaround, the restored lighthouse looks out of place. Its quaint architectural style and distance from the water's edge cause most visitors to do a double-take when they first see it.

Main Duck Island

ONTARIO

The Main Duck Island lighthouse, located in Lake Ontario 12 miles (19 km) off Prince Edward Point, was built in 1913-14 to guide mariners around the hazardous shoals extending from the peninsula. The 80-foot (25 m) octagonal white concrete tower was topped by a polygonal red iron lantern equipped with a third-order lens and a 55 M/M vapor light of 100,000 candle power. It produced a flashing white light every six seconds and had a visibility of 17 miles (27 km). In 1949 a 400-watt mercury vapor bulb replaced the mantle-type burner.

In 1915 a fog station was built near the lighthouse. This station housed a radio beacon so that ships equipped with radio direction apparatus could determine their position. In 1965 a concrete-block fog building was erected to house the generator that powered the fog alarm system.

Various legends surround this lighthouse. One tells of treasures buried on the island from the days of rum-running. Another tells of a large boulder carved with the year 1779 and an arrow pointing to gold. (No gold has ever been found.)

The islands off Traverse Point have been called Isles du Coulages (Islands of Shipwrecks). Sixty-five percent of all shipwrecks on Lake Ontario have occurred in a 30-mile (48.6 km) strand between Point Petrie and Main Duck Island. This high accident rate led to another legend. Lining the tree-lined shore of Main Duck Island is a row of graves. Legend claims that dying sailors dug their own graves here and buried each other one by one until the last died in his own open grave. This eerie story certainly bespeaks the island's isolation.

Visit on a calm day, because the scenic island requires a two-and-a-half to three-hour boat trip. Boats can land at the island at the public dock in Schoolhouse Bay but it is on a first-come-first-served basis.

Nine Mile Point

ONTARIO

Nine Mile Point lighthouse is situated on the southwest point of Simcoe Island and serviced by the world's shortest cable-driven ferry from the west side of Wolfe Island. The lighthouse is about 3 1/2 miles (5.6 km) southeast of Kingston, Ontario, near the entry of the St. Lawrence River from the east end of Lake Ontario. Despite a later construction style, Coast Guard information says it was built in 1833. A 1,000-pound (373 kg) fog bell was installed for $1,000 in 1873. In 1874 the fog bell received clockwork machinery and a striking apparatus. In 1876 a 7-foot-diameter (2.15 m) stone-floored, twelve-sided iron lantern was added. The lighting system included seven mammoth flat-wick lamps (three with fountains and four with reservoirs) and seven reflectors. In 1880 repairs were made to the stone breakwater.

In 1886 an additional 10 acres (4 ha) were added to the original five acres. In 1892 the fog bell was moved to a more prominent position on the point. William Ashe, of Ottawa, was contracted to establish a steam foghorn to replace the bell in 1894. The fog signal was an eight-second blast followed by twenty-two seconds of silence. The horns, pointing southwest out over the lake, were elevated 16 feet (5 m) above the water. The house foundation and tower were built of limestone picked up on or quarried along the shore. The tower walls were 2 1/2 feet (.8 m) thick and had a winding stone staircase of forty-eight steps up the 40-foot (12.5 m) tower to the dodecagonal lantern.

When the station became 15 acres (6 ha) the keeper was allowed a cow and a horse. With the addition of a vegetable garden, he was self-sufficient. By 1945 a new road made the lighthouse more accessible. During the 1950s the old keeper's house was replaced with two modern ones for the keeper and his assistant.

When the last keeper retired in 1990, the light and fog signal was fully automated, and in 1991 the fog alarm was discontinued. The light was extinguished in 1994.

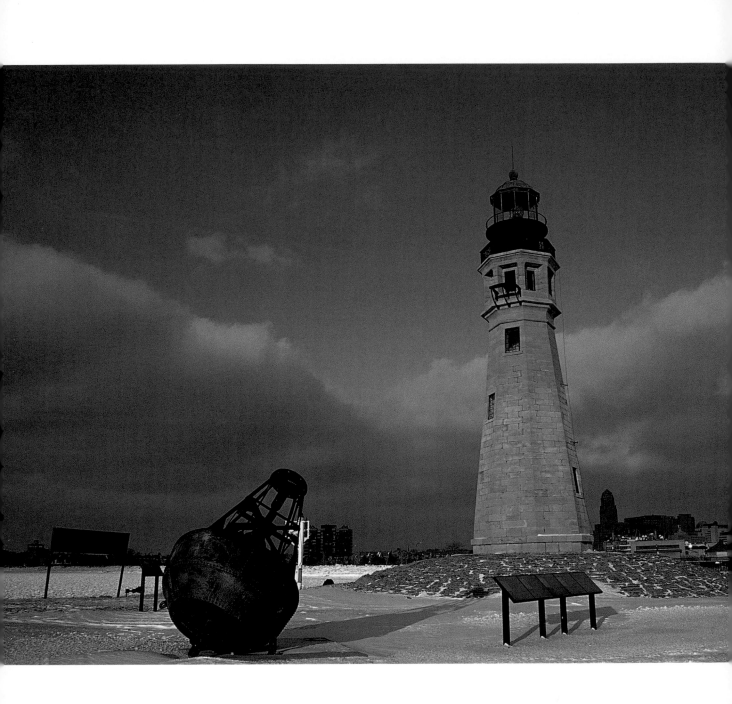

Old Buffalo

NEW YORK

The first lighthouse in Buffalo was built in 1818 to mark the entrance to the harbor of the Buffalo River. The 30-foot (9 m) stone tower was one of two built on the American side of the Great Lakes in 1818. (The other was on Presque Isle, in Pennsylvania.) Its low height and weak light, combined with the wood smoke haze from Buffalo, frequently made it difficult to see. When lake traffic increased after the opening of the Erie Canal in 1825, a new light was needed. The replacement light was built in 1832-1833 at the end of a 1,400-foot (430 m) stone pier. The 44-foot (13.5 m) octagonal tapering tower was constructed of hand-hewn, buff-colored Queenston limestone.

The first lighting apparatus was a Lewis-Argand lamp that burned sperm-whale oil. A parabolic reflector magnified the light out over the water. In 1857 the original lantern was removed and extra stories were added to accommodate a fog bell and a new Fresnel lens with a focal plane 76 feet (23 m) above the lake level.

Each lighthouse has its own flash pattern. During the 1800s the Buffalo light exhibited a fixed white light. By 1905 white lights were becoming confusing when set against the background of city lights, so a new revolving lens was ordered from Europe. The new lens flashed a powerful white light every five seconds.

During 1913 a hurricane-force wind screamed across the Great Lakes, claiming more than 250 lives and a dozen ships, including the light vessel *82,* a Buffalo lightship stationed 13 miles (21 km) southwest of Buffalo. Among the wreckage washed ashore was a piece of wood with a message written in pencil from the captain to his wife. The inscription read, "Good-bye, Nellie, the ship is breaking up fast, William." The shipwreck was found a year later, two miles from its lightship station. The wreck was raised, repaired, and returned to service.

The old lighthouse had various nicknames. During the nineteenth century it was called the Old Stone Light. This changed to Chinaman's Light in the early twentieth century because a nearby watchtower stationed border guards watching for illegal Chinese immigrants crossing the river at Fort Erie, Ontario.

In 1987 the Buffalo Lighthouse Association and the United States Coast Guard restored the lighthouse. In 1988 the open house at lighthouse drew six times more people than lived in the area when the Buffalo light was built in 1818.

This tower is the second oldest surviving structure in Buffalo and the oldest one still on its original site. Appropriately, this lighthouse is depicted on the city seal. Having once marked anchorage in a shallow creek mouth, it is now part of the seventh busiest port in the world.

Barcelona

The Barcelona lighthouse was one of the earliest built on the Great Lakes. A rough-cut stone structure and a rustic architectural style proclaim its early vintage. Congress appropriated $5,000 in 1828 to build this thick-walled 40-foot (12 m) lighthouse within a year at Portland Harbor (now Barcelona) on Lake Erie, as a port of entry and to assist navigation for the increased shipping that would occur when the Erie Canal opened.

Eleven patent-oil lamps and eleven 14-inch (35 cm) reflectors first lighted the lantern. Then, in 1831, residents discovered a natural gas deposit underneath the local creek bed. An inventor ran a pipeline from this gas pocket to the lighthouse through hollow wooden pipes. When the valve was turned and the jets were ignited, the light was visible for miles. This fueled the light until 1838, when the gas ran out and oil was again used.

The first lighthouse keeper was a local clergyman, Joshua Lane. The lighthouse was decommissioned in 1859 when the Lighthouse Board discovered that Barcelona did not have a harbor. The lighthouse was sold at an auction in 1872 and has remained in private ownership since.

The Barcelona lighthouse was the only lighthouse ever fueled by its own natural gas deposit and was the first public building to be illuminated with natural gas.

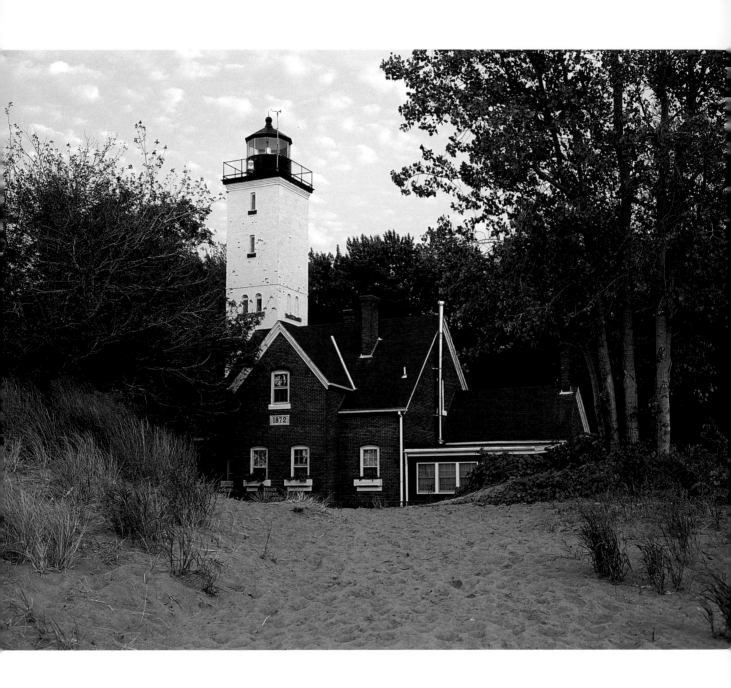

Presque Isle

PENNSYLVANIA

This lighthouse, situated on a 7-mile (11 km) sandy arm of land that curves out into Lake Erie, warns mariners of the Presque Isle peninsula. An Erie native legend tells of the Great Spirit protecting warriors caught in a storm while fishing on Lake Erie. After the storm, the Great Spirit left a giant sand bar where he had placed his arm as a shelter and harbor of refuge for the Great Spirit's favorite children, the *Eriez*.

During the War of 1812, Commodore Perry built six of his nine vessels in Misery Bay, which was protected by this peninsula. After fighting in the battle at Put-in-Bay (near Sandusky, Ohio), Perry and his men stayed at Misery Bay because of threats of another British uprising. Many of his men died of smallpox during the winter of 1813-1814. Their bodies were buried near an adjacent pond that became known as Graveyard Pond.

Construction of this lighthouse began in September 1872. After a scow sank with six thousand bricks aboard, the lakeside was deemed too dangerous and a crude roadway was constructed to connect the station with Misery Bay on the mainland side of the peninsula. Today this roadway is known as the Sidewalk Trail.

Construction of the lighthouse was completed in 1873 and ready for service in July. The total cost was $15,000. The tower was originally only 40 feet (12 m) high to its steel balcony, but in 1896 an additional 17 feet (5 m) were added. As a result, the light stands 63 feet (19 m) above the ground and the tower is 70 feet (21.5 m) to the top of the ventilator ball.

The original light is a fourth-order Fresnel lens that used whale oil for a visibility of 15 miles (24 km). It had two red and four white flash patterns.

The keeper's house is a formidable red-brick two-story structure with ten rooms. The inside of the house retains its nineteenth-century French architectural design, including rounded corners and handcrafted woodwork.

The first keeper was Charles Waldo. After seven years on the peninsula, he described it as "the loneliest place on earth."

Today the residence houses employees of the Presque Isle State Park. The light (which now flashes a white light) is in the Register of Historic Places and is maintained by the United States Coast Guard, with a small museum onsite for visitors.

Ashtabula

OHIO

In 1836 the first Ashtabula lighthouse was built on the east pier entrance to replace the lantern hung on the pier. This three-story tapering tower was hexagonal and of board-and-batten construction, with twelve-paned windows at the top of each side, just below the gallery. The light had seven sperm-oil lamps.

In 1876 a taller lighthouse was built on the west pierhead, with a new fourth-order Fresnel lens. In 1896 a duplex keeper's house was built on top of a hill a short distance from the lighthouse. The keepers and assistants alternated duties at the lighthouse and made their relief trips by boat.

In 1905 another lighthouse was built, this one about 2,500 feet (769 m) north of the previous location. The new light was a large two-story building at the end of a new breakwater. A round tower, lantern and gallery extended up from the square-based building. This lighthouse used the fourth-order Fresnel lens from the preceding lighthouse and had a fixed red light and a first-class siren signal.

In 1916 the old building and tower were moved 1,800 feet (553 m) northeast of the 1905 light to a new crib and foundation where the breakwater was extended. An air-operated diaphone fog signal was installed. The Coast Guard became responsible for the light in 1939. In 1959 a new fourth-order Fresnel lens was installed, with a light that flashed every five seconds. Its visibility was 17 miles (27 kilometers).

This station was manned until 1973, when the light was automated and an electric fog signal was installed. The light is maintained by the United States Coast Guard, accessible by boat only, and is not open to the public. The Coast Guard sold the keeper's house to private owners when they demanned the station. After several private owners, in 1984 the Astabula Historical Society converted it into a marine museum that opens during the tourist season. In 1995 the fourth-order Fresnel lens was finally placed in the museum. Its replacement was a plastic, fiberglass, and aluminum lamp with a 300 mm lens powered by two 12-volt solar batteries.

The Ashtabula Lighthouse is one of ten Ohio lighthouses on the United States National Register of Historic Places.

Lorain West Breakwater

OHIO

L orain's first lighthouse, circa 1859, was built soon after Lorain emerged as a steel and shipbuilding center. James Connelly, the first lighthouse keeper, served from after the Civil War until 1903. Connelly and his assistant walked out each day to the end of the pier to attend the lard-oil lamps.

The City of Lorain developed quickly during the late 1800s. The Johnson Steel Company moved to Lorain in 1894. Cleveland Shipbuilding began in 1897. New ships, old ships, ore boats and stone-carrying vessels regularly moved in and out of Lorain Harbor on the Black River.

In 1917 the Army Corps of Engineers constructed the Lorain West Breakwater Lighthouse with thick concrete-and-steel walls designed to survive the fiercest Lake Erie storms. The building was three and a half stories high, including its raised basement, which housed a water pump, oil tanks and a paint locker. The lantern had a Fresnel lens that magnified the light source to 50,000 candlepower.

In 1966 the light was by an automated 3.5-million-candlepower light on a 60-foot (18.5 m) steel tower. The Fresnel lens was removed from the old tower and a small red marker light added.

The United States Coast Guard scheduled the old lighthouse for demolition, but concerned citizens formed a "Save the Lighthouse" committee. When the government "excessed" the light, the Lorain Historical Society purchased the lighthouse. They sold in 1990 to the Port of Lorain Foundation Inc., a non-profit group that is restoring the lighthouse and creating a museum.

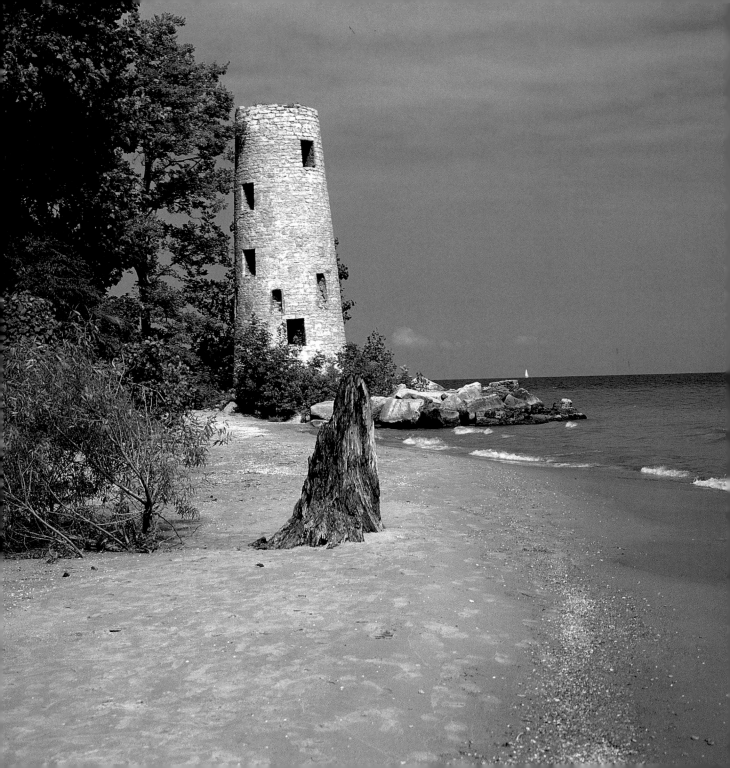

Pelee Island
ONTARIO

Pelee Island is located just 9 miles (14.5 km) south of Point Pelee, on the Canadian shore of Lake Erie, and just 8 miles (13 km) north of Kelly's Island, which is American owned. Pelee Island is Canada's most southern point, and its climate is moderated by the surrounding waters. In the early times the island was important for its timber and for its stone quarries. A century ago the island's economic focus became fishing, grapes, and summer tourism. Drainage canals allowed farmers to grow tobacco and, during the Depression, soy beans.

In the early 1800s water travel through the Pelee Passage was most difficult due to the dangerous reefs and shallow waters. In 1832 the Legislative Council of Upper Canada appropriated 750 pounds sterling for construction of a lighthouse on Pelee Island. This was the second lighthouse built on the Canadian side of Lake Erie. John Scott of Detroit was contracted to do the work, and the stone lighthouse, 40 feet (12 m) in height, was completed in the fall of 1833. The northern point of land known as Brushy Marsh Point was donated for the lighthouse by William McCormick, who also quarried the stone for the structure from his own island quarry.

The light was a combination of lamps and reflectors. There were four circular and eight dual-burner fountain lamps, and twelve 14-to-18-inch (35 to 46 cm) reflectors. It was originally a fixed white catoptric light. Its visibility of 9 miles (14.5 km) was sometimes described by mariners as "lacking in strength." During its first year of operation the lighthouse ran out of oil in September.

In the winter of 1838, during part of the "patriot uprising" in Upper Canada, patriots invaded Pelee Island from Sandusky, Ohio, and took over the island. During the invasion, lamps and reflectors were stolen from the lighthouse. The McCormicks left the island for the safety of the mainland. Soldiers from Fort Malden and a group of Indians marched across the ice to do battle and drive the patriots from Pelee Island.

Visitors can take the ferry from Point Pelee to Pelee Island and then drive across the island to Lighthouse Drive. Follow the sign marked Ye Olde Lighthouse Trail. The trail crosses a small muddy marsh to a sandy beach south of the now dilapidated lighthouse.

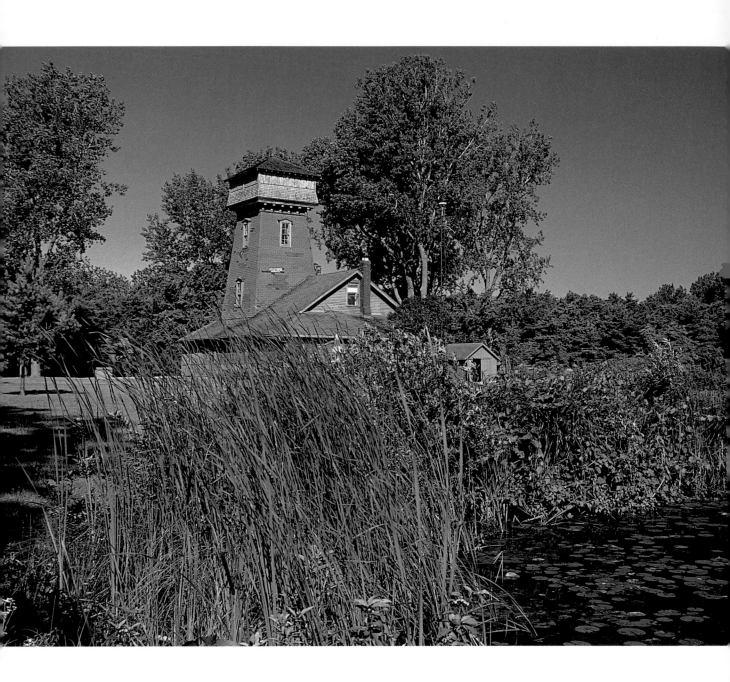

Old Long Point Cut

ONTARIO

Long Point, Ontario, has been labeled the "Graveyard of the Great Lakes" because so many ships have sunk or run aground in these waters. As early as 1679 De La Salle's barque, *Le Griffon,* narrowly escaped the point during a heavy fog. So many schooners were shipwrecked here in the 1800s that they are referred to as the "Ghost Fleet of Long Point."

To avoid the treacherous water and sandy shoals around the 25-mile (40 km) tip, small craft were portaged over the narrow isthmus during the late 1700s and the early 1800s. Schooners and steamers had to go around, despite the danger of the fast-approaching storms and treacherous shoals of Lake Erie.

By 1829 the House of Assembly for Upper Canada was petitioned for funds to build a canal across the peninsula. But Mother Nature sent a series of storms that eventually created a channel 20 feet (6 m) deep and a 1/2 mile (.8 km) wide. This channel became known as "The Cut."

In 1879 a lighthouse east of The Cut replaced the lightship that was moved to Kingston. Unlike those built on the point with separate tower and keeper's house, this isolated lighthouse had its tower on the northwest corner. The white wooden tower and house were built on a 1-foot-thick (.3 m) stone foundation, which housed a full basement. The wide-based square tower tapered up three stories, fifty-three steps, to a 10-foot (3 m) square gallery surrounded by a wooden railing and ornamental braces. With its dodecagonal lantern, the tower's height was 60 to 65 feet (18.5 to 20 m). A red lamp above a white one, with a visibility of 12 miles (19 km), identified The Cut.

The Cut's distinctive red-and-white light was both a blessing and a curse. The Cut meant safe harbor during stormy weather, but pirates, or "blackbirds" as they were known, copied the light's distinctive symbol to lure ships aground on the sandy shore. While the crew fled for their lives, the pirates plundered the cargo. By the time the authorities arrived, the blackbirds were long gone.

The government furnished the lighthouse with supplies and keepers, and in 1908, a telephone line. Lighthouse keepers included Esley Woodward, William Dickson and Frank Mason.

Decommissioned in 1916 due to silt and shifting sands, the government sold the lighthouse to a private owner, who turned it into a rental cottage. After a series of owners, Ewart Ostrander of Tillsonburg bought the lighthouse in 1968 as a private dwelling.

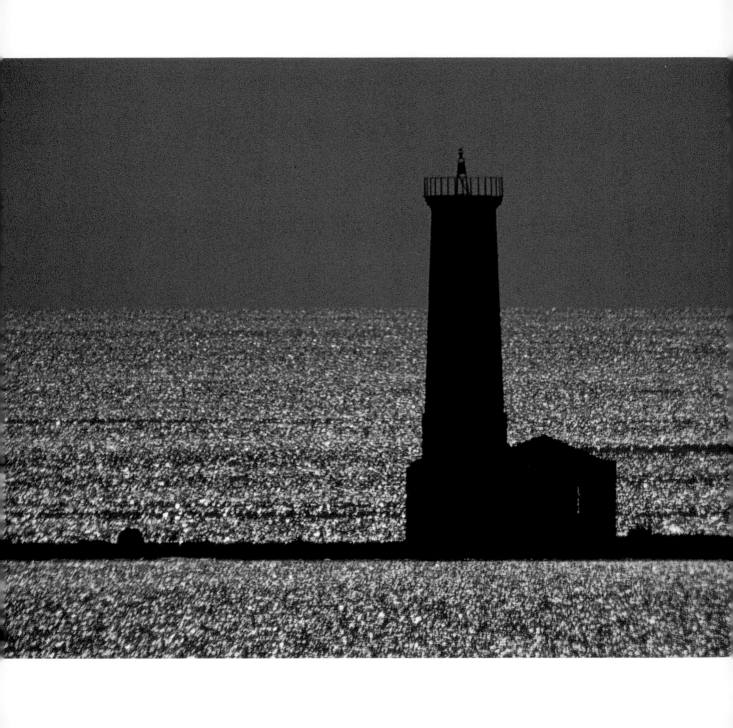

Mohawk Island

ONTARIO

In 1829 the first Welland Canal was completed and lake travel on eastern Lake Erie increased as a result. A feeder canal brought extra water from the Grand River at Port Maitland for vessels using the Welland Canal. This feeder canal only had a draft of 4 feet (1.2 m) but many smaller boats used it as an alternate route. Finally, Port Maitland harbor needed a lighthouse.

The government contracted, a Scottish stonemason, John Brown of Thorold, to build the lighthouse in 1846. He used stone from the Queenston quarry to build the 64-foot (19.5 m) tower and keeper's dwelling on Mohawk Island. Due to his meticulous methods and the ornate stonework he crafted, it took him two years to complete the project. During the War of 1812 a naval reserve had been situated on the point and blueprints had been drawn up for a lighthouse in the area to mark the reef. When Brown was contracted to build the lighthouse he was given these 1816 blueprints. The lighthouse was finished in 1848. It was built on small, rocky, barren Mohawk Island, about 2 miles (3.2 km) southeast of Port Maitland, the only available spot for a lighthouse offshore to mark the dangerous reef. It was the first lighthouse to be built on an island in Lake Erie.

In addition to the Mohawk lighthouse, John Brown later built seven more stone lighthouses for the Canadian government, including his famous Imperial Six lighthouses in 1858-1859 on Lake Huron and in Georgian Bay.

The first lightkeeper at Mohawk Island was John Burgess, a farmer from Burgess Point, who earned sixty-five pounds sterling per year. The last keeper was Richard Foster. After closing the lighthouse for the season in December 1932, Foster and his son were caught in the ice floes while boating the 2 miles (3.2 km) to shore. They were found dead from exposure.

The government left the lighthouse unmanned and converted the light to battery power. Because of vandalism, in 1969 the government replaced this light with a floating reef buoy. Only public outcry stopped the razing of the lighthouse by the Department of Transportation. Today local marina operator Mike Walker and the Mohawk Lighthouse Preservation Association lead restoration efforts that began in 1990.

Although the island is barren, the lighthouse shares the rock with a variety of birds, including herring gulls, cormorants and rock doves. The island is a bird sanctuary overseen by the Canada Wildlife Service. This island is off limits to visitors during nesting season, from April 1 to August 1.

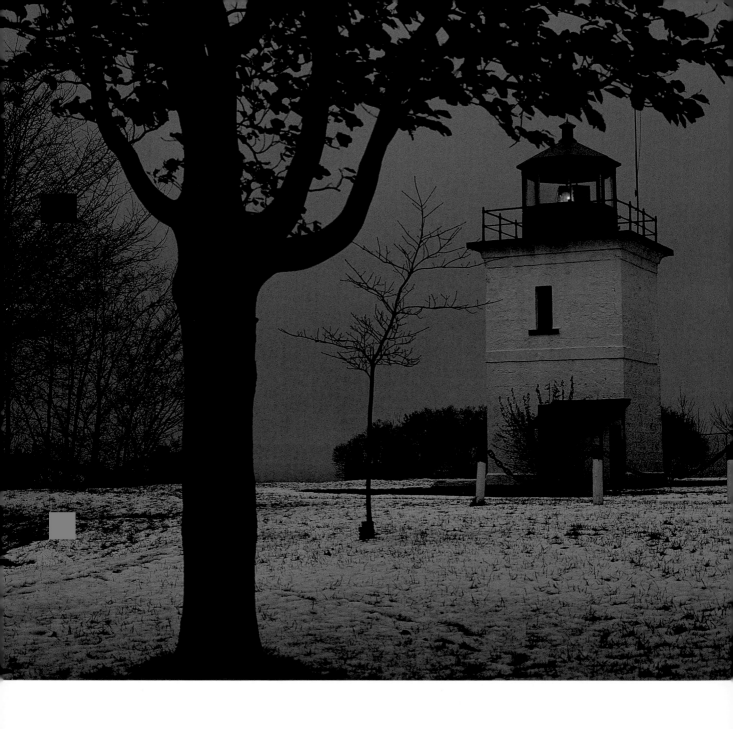

Goderich

ONTARIO

The first inhabitants at the mouth of the Maitland River, the Chippewa people, called the river the *Menestung*, which means "healing waters." The first Europeans called it the Red River. John Galt, an Ayrshire man, incorporated the Canada Company in 1824, then purchased 1 million acres (404,700 ha) of land called the Huron Tract from the British government. This land extended 8 miles (13 km) north of Goderich along the eastern shore of Lake Huron and east to the community of Guelph.

To bring in settlers Galt chose the natural harbor at the mouth of the Red River. In 1827 he and William "Tiger" Dunlop, on behalf of the Canada Company, founded the town and port of Goderich in this location. In 1839 the river was named the Maitland in honor of Sir Peregrine Maitland, the Lieutenant Governor of Upper Canada. Between 1830 and 1850 the Canada Company spent over sixteen thousand pounds sterling on the harbor, building wharves, piers and lighthouses, but harbor conditions were always poor.

The lighthouse built in 1847 was situated on a high bluff overlooking the river basin. The square 33-foot (10 m) whitewashed stone tower with a square red parapet supported an octagonal lantern. A separate keeper's quarters was built close by. The mercury vapor lamp produced a signal that had a flash of half a second, followed by a five-and-a-half-second eclipse, and then another flash of half a second. The lamp was lit year-round. There were 153 steps leading from the lighthouse bluff to the harbor below.

In 1872 the Canada Company built two piers and commercial docks, but silt from nearby sandbars damaged them. The town council received a government grant of $20,000 in 1873 to build breakwaters and piers to separate the harbor from the mouth of the river. In November 1913 a fierce storm swept off Lake Huron. A plaque at Goderich reads in part: "…The storm, which ravaged the Great Lakes region for three days, destroyed a total of nineteen vessels and resulted in the stranding of nineteen others with the loss of two hundred and forty-four lives." It was alleged that the foghorn was never sounded.

The high vantage point of Lighthouse Park is the perfect spot to watch the spectacular sunsets over the lake. The lighthouse is threatened with "excessing" by the Canadian government on or before 2002.

Chantry Island

ONTARIO

With the development of the Saugeen peninsula in 1855, public calls for navigational aids warning of sandbars and shallow water were no longer ignored. The Department of Public Works contracted John Brown of Thorold to build eleven lighthouses to light Lake Huron and Georgian Bay from Point Clark to Christian Island. Because of their expense, only six were completed. These were Cove Island, Nottawasaga Island, Griffith Island, Chantry Island, Point Clark and Christian Island. Their caps were more rounded than those of most lighthouses. Perhaps it was because of this feature that they became known as the Imperial Towers, or perhaps it was due to their cost, which increased dramatically during the construction period.

Each tower was built of white dolomite limestone that had been carefully selected to be free of cracks so moisture could not penetrate the structure. The limestone was topped with granite, which supported the heavy, red cast-iron polygonal lantern necessary to stabilize the Argond (sp?) lamp and the large Fresnel lens. The oil-burning lamps produced so much water vapor that interior eavestroughs were used to drain the water out through spouts concealed in the lions' heads located at the top of the junction of each glass panel.

Chantry Island is located 1.4 miles (2 km) southwest of the mouth of the Saugeen River at South Hampton. The Chantry Island lighthouse was first lit on April 1, 1859, using a steady white light with a visibility of 17 miles (27 km). It is 86 feet (26.5 m) tall, with 115 steps leading to the lantern room that housed a second-order Fresnel lens.

The first lightkeeper at Chantry Island was Robert Mills. From 1855 to 1857 he kept a lantern hung from a pole on the lighthouse tower. At the time the light was officially lit, the keeper was Captain Duncan Lambert (1859-1879). His salary was $435 per year.

During a storm in 1908, the schooner *Erie Stewart* struck the dock and destroyed the range light while seeking refuge. The ship was abandoned and sank. The ruined lighthouse and the damaged dock were never reconstructed. All that remains today are the rock cribs, still visible beneath the water's surface.

In 1954 the Chantry light became electronically operated and the lightkeeper's position was phased out. On December 20, 1957, the Canadian Wildlife Service declared Chantry Island a migratory bird sanctuary.

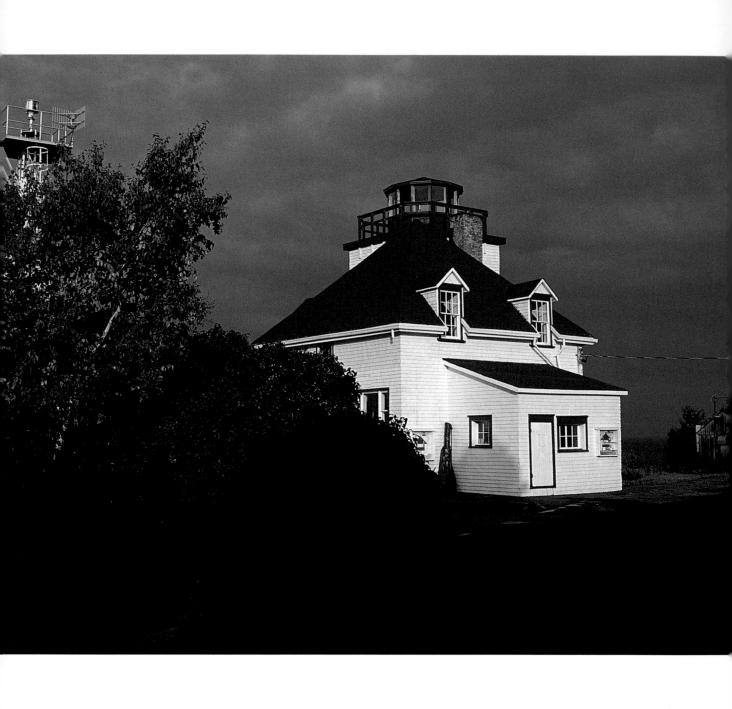

Cabot Head

ONTARIO

Located at the tip of the Bruce Peninsula, Cabot Head was crucial for Great Lakes navigation. It was also the site of many well-documented shipwrecks in the 1800s. The nearest harbor, Wingfield Basin, had natural shelter, but its shallow entry point was suitable only for small boats.

John George of Port Elgin was awarded a contract valued at $3,475 in 1895 to construct a wooden lighthouse and steam fog-alarm at Cabot Head within the year. The lightkeeper's position, a political appointment, was awarded to a Conservative, but before he could begin, the Liberals defeated the Conservatives in 1896 and the position was awarded to S. J. Parke. In 1898 Charles Webster Sr. took over as lightkeeper for the next eight years. During his tenure, a forest fire destroyed the station.

In 1906, with the next change in government, the new lightkeeper became Leslie Martindale. An unstable phone line was strung across treetops to the lighthouse in 1915, while he was still keeper.

In 1926 Howard Boyle was awarded the position of lighthouse keeper because he was a veteran of the First World War. Described as a workaholic, Boyle went beyond his routine lighthouse duties. He was an avid gardener, a landscape designer, and kept a cow, a pig and chickens. His gardens still flourish today.

In 1951 Harry Hopkins became keeper. In the fifties, Hurricane Hazel destroyed the boathouse and dock. In 1958 a cottage was built for the keeper, and in 1963 the road from Dyer's Bay was constructed.

With the coming of an automatic fog-alarm system, a metal tower for a new light, and electricity, the manned lighthouse slowly became history. By 1988 the light station was completely automated.

In the early 1990s the Friends of Cabot Head received grants and donations to restore the building and maintain a visitors center. Wingfield Basin is now a designated Nature Reserve. Visitors are welcome between the spring thaw and the first snowfall.

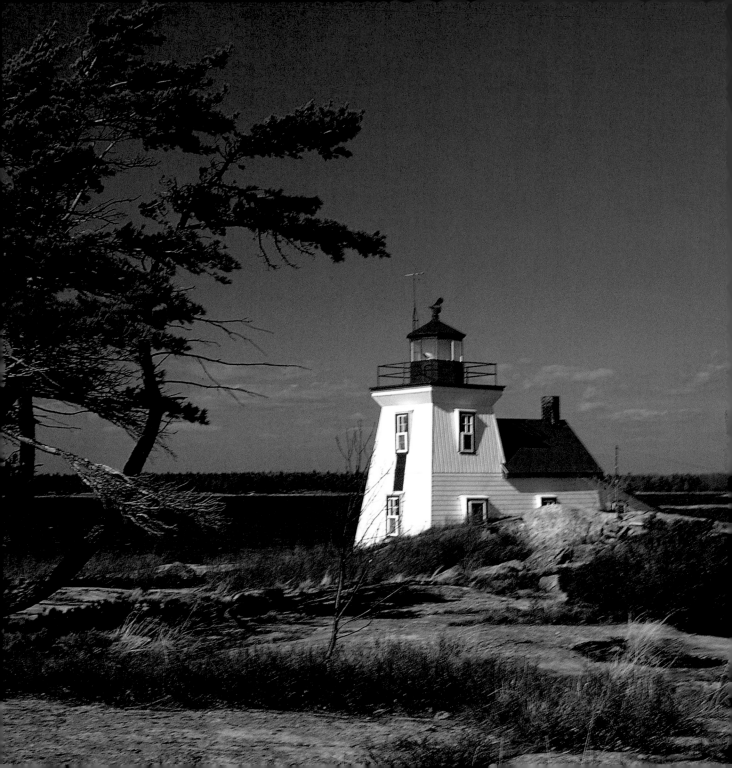

Brebeuf Island

ONTARIO

Brebeuf Island, a typically small, rocky Georgian Bay island with windswept pines, is located about 7 miles (11 km) from Midland, Ontario, on Lake Huron. Lighthouses were added around the turn of the century to assist loggers, vacationers, and supply boats. The light built in 1900 was one of two range lights used to mark the entrance to Sturgeon Bay and the communities of Penetang, Midland, Victoria Harbor, Port McNicoll, and Port Severn. The original Brebeuf Island lighthouse, built in 1878 on Gin Rock, was moved to Brebeuf Island in 1900. Its wood-frame construction was placed on a stone foundation. The fixed white light used coal-oil vapor lights and reflectors. Today the light is electric, with a visibility of 10 miles (16 km).

This lighthouse had only two keepers. The first keeper, William Baxter, stayed at Brebeuf Island lighthouse from 1900 until 1931. Clifford Paradis was keeper from 1931 until 1962.

Because of the light's isolated location and infrequent visits from supply ships, these keepers were necessarily frugal and often used storm-tossed logs as firewood and to replace the dock when it washed away during storms. In addition to maintaining this light, they risked their lives rowing in stormy seas to light the rear range light on the west shore of Beausoleil Island.

A century later, this lighthouse is still busy. During the summer months, vacation boats travel from Georgian Bay to the Trent-Severn Waterway, as well as the entrance to Sturgeon Bay. Because of the heavy water traffic, the Canadian Coast Guard activated the In-Shore Search and Rescue Center on the island in 1998. It is manned from May 24 to Labor Day.

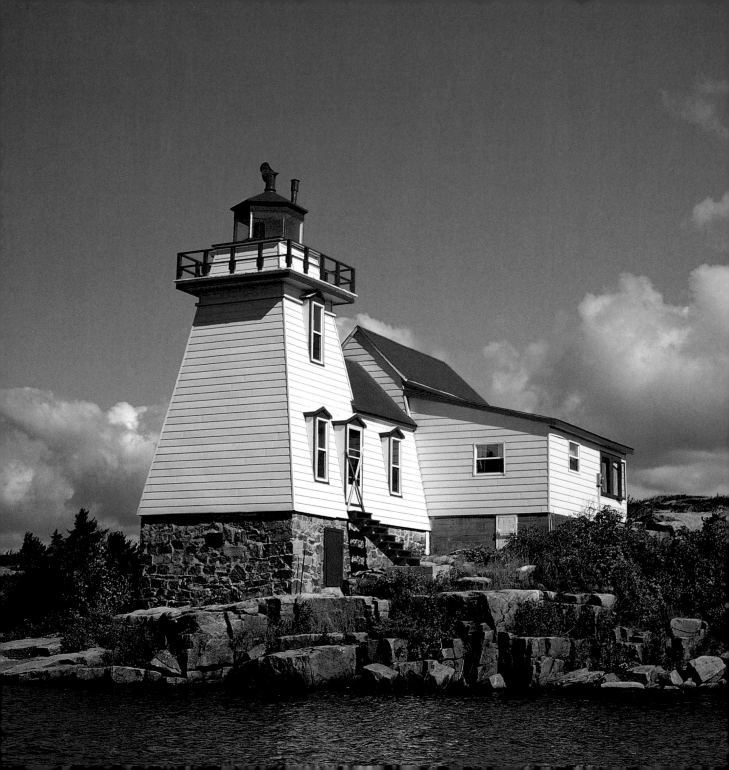

Pointe au Baril

ONTARIO

The first lighthouse at Pointe au Baril was a lantern set on top of a barrel at water's edge to guide local fishermen back into shore at dusk. (Pointe au Baril is French for "point of the barrel.") Later the barrel was placed on its side and a lantern was set inside it as an early type of range light. This was a significant improvement. As long as the fishermen kept the light visible, they had a safe passage past the rocks and dangerous shoals into the harbor.

In 1881 lumbering companies paid the McIntoshes, a local fishing family living on McIntosh Island on Georgian Bay, to keep lanterns lit at night, including Pointe au Baril, to guide tugs towing log booms through the channel and into the harbor.

In 1887 lumber companies petitioned the government to build two simple derrick-style lighthouses as range lights in the channel, but the government wanted more substantial structures.

The front range light built on Pointe Au Baril was a white, square, tapering tower 33 feet (10 m) tall on a 10-foot-high (3 m) stone foundation. The tapered walls of the house appear braced for Georgian Bay storms. Both the house and the tower are trimmed in red. A polygonal lantern sits on top of the tower. The fixed white dioptric light has a visibility of 10 miles (16 km).

Charles Mickler of Collingwood was contracted to build the lighthouse and range lights, and finished them in 1889 at a cost of $1,515. The government refused to pay, claiming Mickler had done unsatisfactory work. The lawsuit was settled in Mickler's favor four years later.

The keeper from 1907 to 1929, Ole Hansen fished, built and repaired boats, and ferried tourists. James A. Vail kept the light from 1930 to 1940. Kenneth Malcolm Evans, whose ghost is said to haunt the property, was keeper from 1941 to 1949. Carl Madigan became keeper in 1949. he supplemented his keeper's salary of $3 per day by doing carpentry and odd jobs, while his wife Emmaline took in laundry and baked pies for the Bellevue Hotel. Her laundry business doubled as a local weather watch. If the laundry was outdoors at the lighthouse, good weather was assured. Carl died in 1977, but Emmaline took over and maintained the light until 1983, when it was automated.

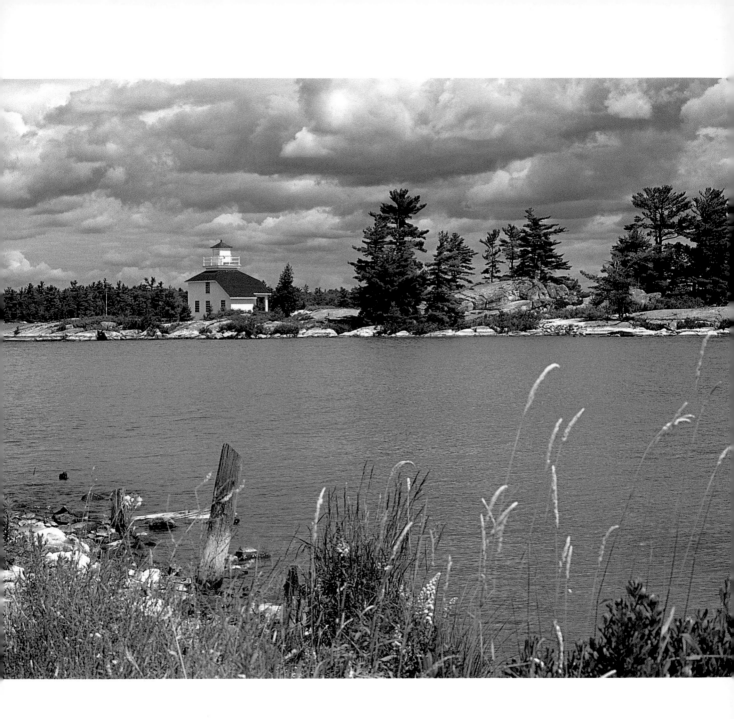

Shoal Island

ONTARIO

Shoal Island is located off the northwestern tip of St. Joseph Island, in the St. Mary's channel. During the mid-1800s mariners using the St. Mary's channel risked hazardous currents, sunken shoals, and rocks. Few captains knew the waters well enough to take their vessels through, so they hired pilots for the stretch from Sault Ste. Marie to Windsor.

Starting about 1861, Philetus Church, who operated a store at the head of Lake George, employed his captain, David Tate, to stake out the channel of the St. Mary's River each spring and remove the stakes in the fall. Later, the Vessel Owners Association installed and maintained range lights through the St. Mary's channel for the protection of their vessels.

The Canadian and American governments finally assumed responsibility for marking the channel. In about 1892 range lights were placed at all dangerous angles. Several of the light ranges were placed on St. Joseph Island. In 1885 the Canadian government built a lighthouse on Shoal Island, at the head of St. Joseph Island, to help mark the north channel. This lighthouse was sometimes called Rains lighthouse, after its first keeper, and sometimes Mathew lighthouse, after an island connected to Shoal Island by a small bridge. St. Mary's Canal was opened for traffic on September 7, 1895. In the event of any future trouble between England and the United States, Canadian boats would not have to rely on American locks.

The Shoal Island lighthouse was a square white building about 34 feet (10.5 m) high. It had a white flashing light with a flash of one second eclipsed by three seconds of darkness. Its first keeper was Evron C. Rains. He and wife Mary had five children and lived on Evron's salary of $150 per year. When he wrote the government asking for a raise, he was informed that it did not take a wife and five children to operate a lighthouse. He did not receive the raise. The couple went on to have an additional five children. Sometime in 1908 or 1909 the lighthouse reportedly burned down and was rebuilt.

The lighthouse logbooks of other keepers can be seen at the St. Joseph Island Museum Village on St. Joseph Island. To see the Shoal Island lighthouse, drive along St. Joseph Island's northern coast, out to a point that curves and narrows to a one-track path at the river's edge. Together the lantern and dome give the appearance of "a cap on a fancy bottle." The red-and-white lighthouse is set against an attractive backdrop of smooth rock, windswept pines and junipers — lake, island, and sky.

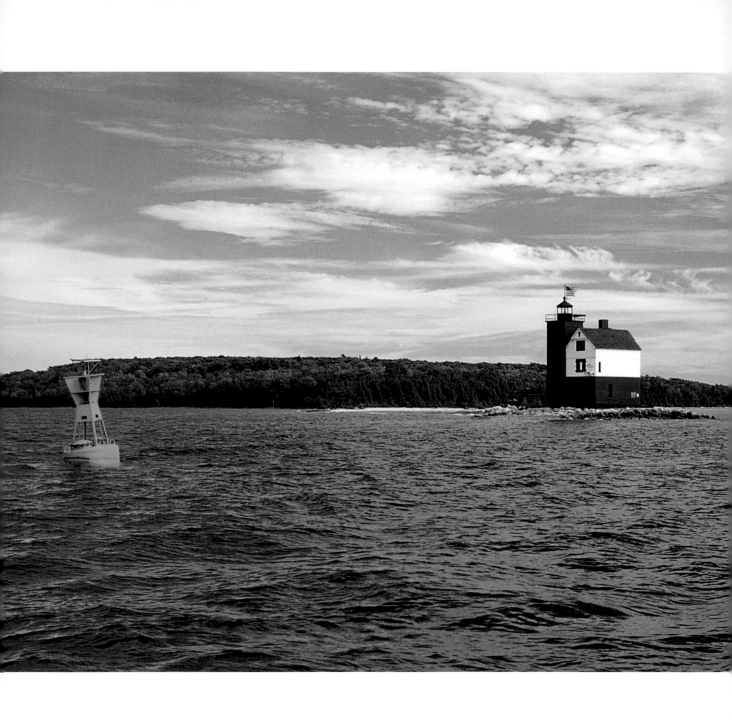

Round Island

MICHIGAN

B efore the Round Island lighthouse was built, cargo ships and passenger vessels passing from Lake Superior to Lake Michigan usually took a longer but safer route that passed south of Bois Blanc Island. Recognizing the convenience of a shorter route, President Ulysses S. Grant reserved land on Round Island for a lighthouse in 1874. But it took over twenty years to build. In 1894 Congress appropriated $15,000. The lighthouse was lit for service on May 15, 1896. A fourth-order Fresnel lens produced a white light with a red flash every twenty seconds, producing a 14 1/2-mile (23 km) visibility.

A red-brick lighthouse with red shingles, a three-story house and four-story tower made for an excellent day marker. Three layers of brick with dead air space between provided insulation. The first floor housed a boiler room for the fog signal and a coal bin. The second and third floors provided living quarters for the keeper and his assistant.

In 1924 the building was painted red and white. In 1938 Round Island — except for the lighthouse and land that it sat on — reverted back to the federal government from the state of Michigan and it became part of the Hiawatha National Forest. In 1939, when the United States Coast Guard took over from the United States Lighthouse Service, the whole lighthouse was whitewashed. At least one keeper was kept at the lighthouse after its light was automated. In 1947, when a light and radio beacon were built near Mackinac Island's west breakwall, the Coast Guard abandoned the Round Island lighthouse.

In 1955 the Coast Guard recommended that the lighthouse be demolished, but instead it was "excessed" or declared surplus. Three years later, in 1958, the Coast Guard transferred it to the United States Forest Service, who classified Round Island as a National Scenic Area. The lighthouse gradually deteriorated from wind, waves, ice, and vandalism.

A severe storm in the fall of 1972 opened a large hole in its southwest corner. In 1974 the Mackinac Island Historical Society and the Hiawatha National Forest agreed to partial restoration and the Round Island Lighthouse was added to the National Register of Historic Places. A feature film, *Somewhere in Time*, was shot at the location, and *Sports Illustrated* used it as the setting for its 1993 swimsuit issue. In 1996 the light was relit and approved as a private aid to navigation.

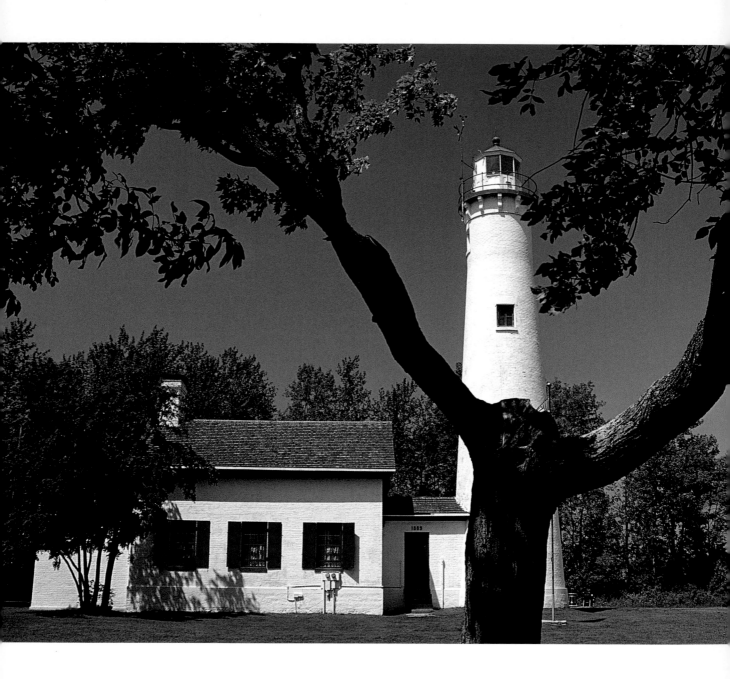

Sturgeon Point

MICHIGAN

A s the population grew and the lake traffic increased on the western shore of Lake Huron, a lighthouse was thought necessary at Sturgeon Point, about 4 miles (6.5 km) north of Harrisville, to mark a reef that reaches 1 1/2 miles (2.5 km) into the lake.

Congress appropriated $15,000 for the lighthouse in 1868, and Perley Silverthorne donated the land at the point. The light was lit in 1870. The conical brick tower rose from a 7 1/2-foot-high (2 m) limestone foundation constructed 4 feet (1.2 m) below ground level. Eighty-four cast-iron stairs led up to the decagonal lantern topped by a red decagonal dome and a ventilator ball, making the tower 70 feet 9 inches (22 m) tall. A round gallery with an iron balustrade surrounded the lantern. The tower lantern housed a Fresnel lens from the lighthouse in Oswego, New York. Bolted to the lantern floor, it displayed a fixed white light that burned kerosene through a double-wick system. The light was visible for 16 miles (26 km).

The keeper's house, also made of brick and painted white, had an 11-foot (3.5 m) covered passageway connecting it to the tower, to keep the lightkeeper dry during inclement weather. The three keepers were Perley Silverthorn (1870-1876), John Pasque (1877-1881) and Louis Cardy Sr. (1881-1913).

In 1876 the Sturgeon Bay Life Saving Station was added on the point. Volunteer crews stayed on duty until mid-December. The United States Coast Guard stationed regular crews at Sturgeon Point after the First World War, until the station closed in 1941.

In 1913 the United States Coast Guard changed the light to acetylene and retired the last keeper. The captain of the lifesaving station moved into the lighthouse with his family. After the lifesaving station was closed, most of the buildings were torn down or vandalized. The tower and keeper's house remained vacant for many years. In 1961 the United States government deeded the Sturgeon Point property to the State of Michigan. The tower light is maintained by the United States Coast Guard and is off limits to visitors. In 1982 Michigan's Department of Natural Resources leased the house and the grounds to the Alcona Historical Society, who restored the lighthouse and refurbished the rooms with donated turn-of-the-century items. A small museum is free and open daily during the summer.

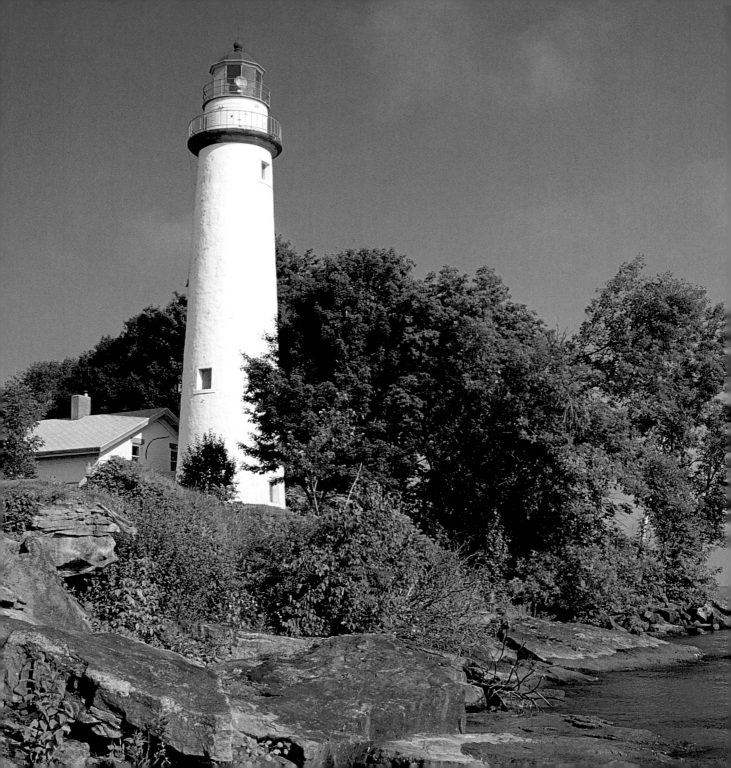

Point aux Barques

MICHIGAN

The Pointe aux Barque lighthouse is one of the few still in operation on the Great Lakes. Built in 1857 under President James Polk's orders, it stands at the edge of a rocky cliff on the east side of the entrance to Saginaw Bay. Pointe aux Barque means "point of the boats." As well as marking the entrance to the bay, the lighthouse warns boats of the shallow waters.

The once red-brick tower, with approximately 4-foot-thick (1.2 m) walls, has been painted white. One hundred-and-three iron steps spiral to the top. Five windows in the tower light the stairs. The lantern is topped with a red dome and a ventilator ball, making it 89 feet (27 m) tall. The flashing white light has a visibility of 18 miles (29 km). Automated in 1957, the light is presently owned and operated by the United States Coast Guard.

A red-brick keeper's house, also painted white, is attached to the tower by a short covered walkway. This house is now a museum with information on the lighthouse, shipwrecks in Lake Huron, and a description of the Thumb Area Great Lakes State Bottomland Preserve, with shipwreck locations noted on maps. Surrounding the museum is the beautiful Lighthouse County Park, with both camping and day-use facilities.

At one time a lifesaving station was part of the lighthouse complex. During the terrible storm of 1913 crews from this station saved the lives of thirty-three people from the *Howard M. Hanna* when it was driven off course and went aground off the point. This lifesaving station was later moved to Huron City, where today it is part of the Huron City Museum, a 7-acre (3 ha) display of early homes and buildings, all furnished with period pieces. Ron and Judy Burkhard, neighbors close to the park, built a scale model of the lighthouse 9 feet (3 m) tall and 9 feet (3 m) long, with a yard light controlled by an electric eye.

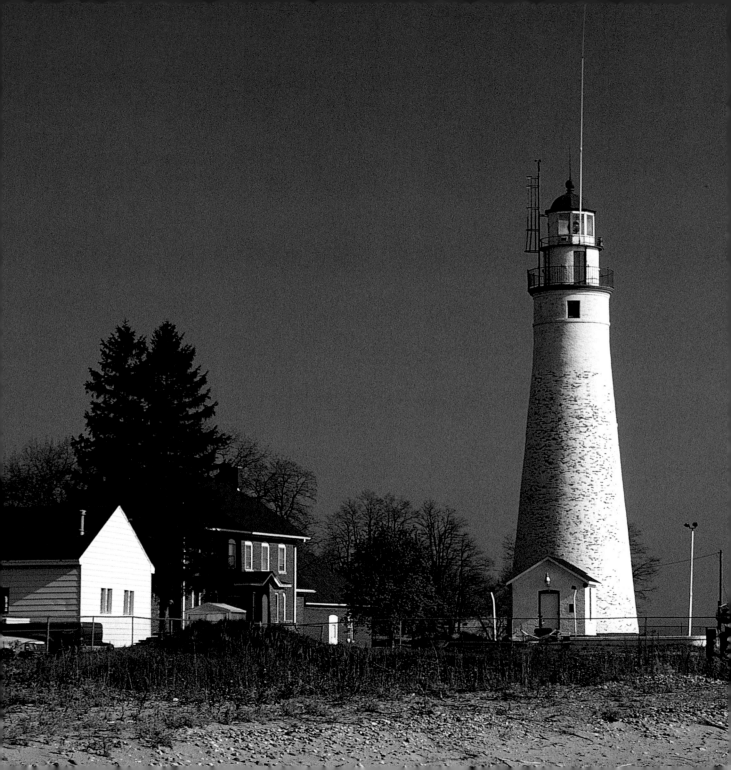

Fort Gratiot

MICHIGAN

I n 1825 a lighthouse by Winslow Lewis of Massachusetts was built at the head of the St. Clair River to mark the treacherous entrance from Lake Huron.

Its first keeper, Rufus Hatch, died six weeks after the light was lit. George McDougal, a Detroit lawyer, had the political pull to become the second keeper. He claimed that the lighthouse was not built to government specifications and deemed the tower to be unsafe. His basement flooded, and he had no root cellar. He used personal savings to survive. His discerning eye was accurate. In September of 1828 a storm undermined the tower and it collapsed two months later.

Replaced in 1829, the current lighthouse was built by Lucius Lyon, who was Deputy Surveyor General of the Northwest Territory and later a United States senator from Michigan. The freestanding 62-foot (19 m), conical tower was made of red brick and painted white with red trim. In 1861, the tower was extended to its present height of 86 feet (26 m). In 1875 a new, red-brick keeper's house was erected. After a storm in 1913, steel pilings were added.

This lighthouse, the first built on Lake Huron, is the oldest surviving light in Michigan. It is even older than the state by eight years. Maintained by the Port Huron Coast Guard Station, the lighthouse is open periodically to the public for tours and to climb the tower.

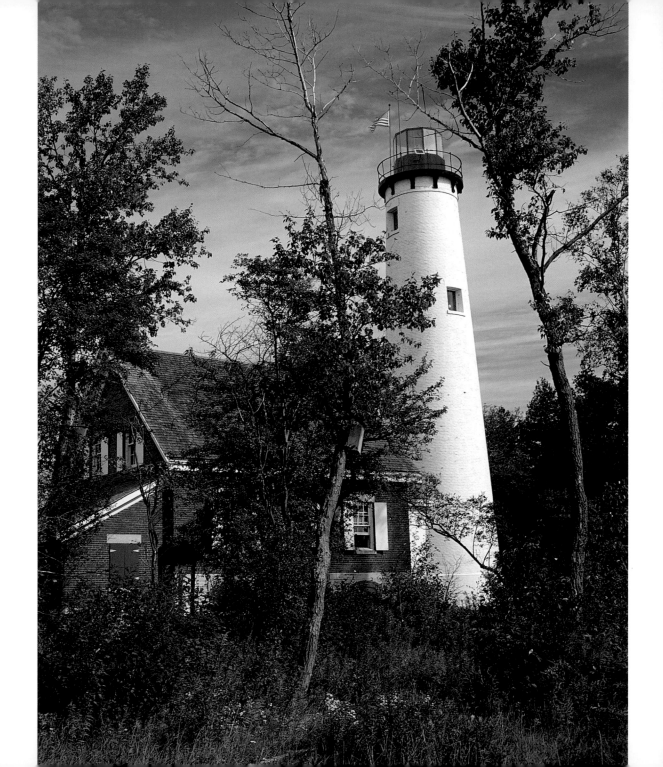

St. Helena Island

MICHIGAN

The Indians called the island at the entrance to the Straits of Mackinac Mish-quo-o-ning, or "beautiful island." In 1744 it appears on a map by Charlvoix under the name St. Helene, probably after Emperor Constantine's mother. A century later, in 1848, William Belote acquired the island from the United States government. During the 1850s St. Helene was a small fishing community and a port of call for steamships taking on fresh supplies and fuel. A firm of brothers headed by Archibald Newton bought the island from Belote in 1853.

In 1867 the Lighthouse Board reported, "This island provides an excellent anchorage during westerly gales. It is nothing unusual to see a fleet of fifty sail into the cove at one time and anchor at the island. It is low, and the mainland to the north of it being high, the island when approached from the southwest, can be seen but a short distance. A light here would be of much service."

In 1872, after several shipwrecks occurred on nearby shoals, Congress appropriated $14,000 for a lighthouse, which was built the following year. The lighthouse has a 71-foot (22 m) conical brick tower connected by a covered archway to a one-and-a-half-story brick dwelling with a privy out back. The early lantern housed a three-and-a-half-order Fresnel lens that used a fixed red light. Its lamp burned lard, then kerosene, and later acetylene.

One keeper suffered a curious accident while painting the tower in his wife's absence. He became caught in the scaffolding and hung upside-down for two days until her return. It was rumored that he was never "right in the head" after the incident.

In 1980 the Coast Guard tore down the boathouse and the assistant keeper's house. In 1985 the Great Lakes Lighthouse Keeper's Association obtained a thirty-year lease from the Coast Guard to restore and use the light station.

In 1988 the St. Helena lighthouse was added to the National Register of Historic Places. The Great Lakes Lighthouse Keeper's Association guided the restoration efforts. The association also offered its first educational program at the lighthouse in 1988.

In 1998 the Great Lake Lighthouse Keeper's Association gained private ownership of the light, and when the coast guard officially turned off the light, it was immediately relit as a private aid to navigation. The association also celebrated the tenth anniversary of its educator's workshops in 1998, as testament to their belief that "our children are the keepers of tomorrow."

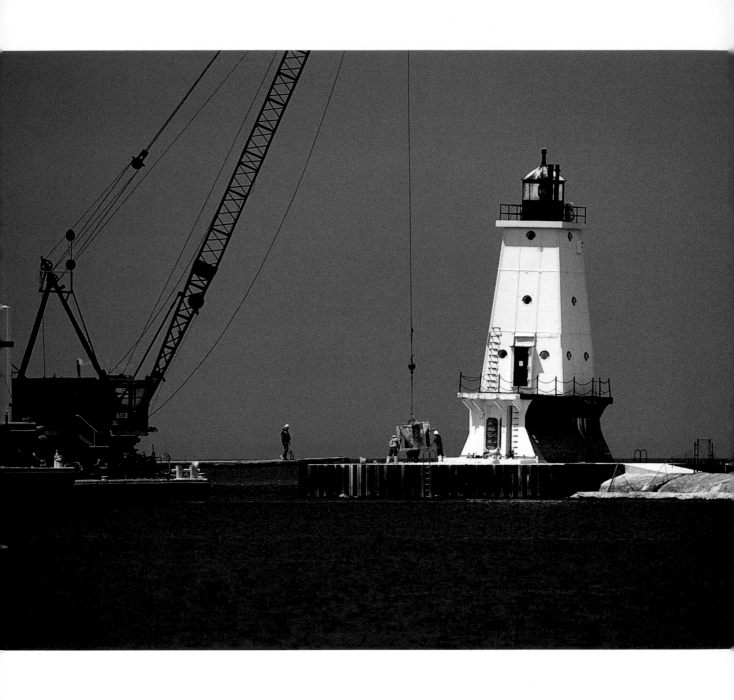

Ludington North Pierhead

MICHIGAN

Congress appropriated $6,000 in 1870, and the Ludington North Pierhead lighthouse and keeper's quarters were erected in 1871 on the south breakwall of the Ludington harbor channel. In 1914, as part of $1 million worth of harbor improvements, it was moved to the north breakwater.

In 1924 it was replaced with the present structure, a square white tower 57 feet (17.5 m) high with a focal plane of 55 feet (17 m). The base has a concrete wedge, and the steel-framed tower with small porthole windows is encased in riveted steel plates for protection from Lake Michigan storms. The square gallery has black steel railing around its polygonal lantern.

The Macbeth Evans Company of Pittsburgh manufactured the original optic, a fourth-order Fresnel lens. It was lit by a two-lamp apparatus bolted into the center of the lens, flashed at four-second intervals, and had a visibility of 19 miles (30.5 km). The light was automated in 1972.

In 1993 the lighthouse was refurbished with new lights, wiring, battery back-up, and paint. The following year, the Army Corps of Engineers discovered the lighthouse base had deteriorated and the tower was leaning. The Gillian Company of Milwaukee installed sheet metal around the lighthouse base and poured concrete below the substructure.

In 1995 the Fresnel lens was dismantled and removed from the lighthouse. The United States Coast Guard loaned the light to the Mason County Historical Society. The society displays the lens, valued at $375,000, in the maritime exhibits building at White Pine Historical Village.

Today the lighthouse's optic is a functional lightweight 300 mm plastic lens, molded in the Fresnel design that flashes four seconds on and one second off, with a visibility of 19 miles (30.5 km).

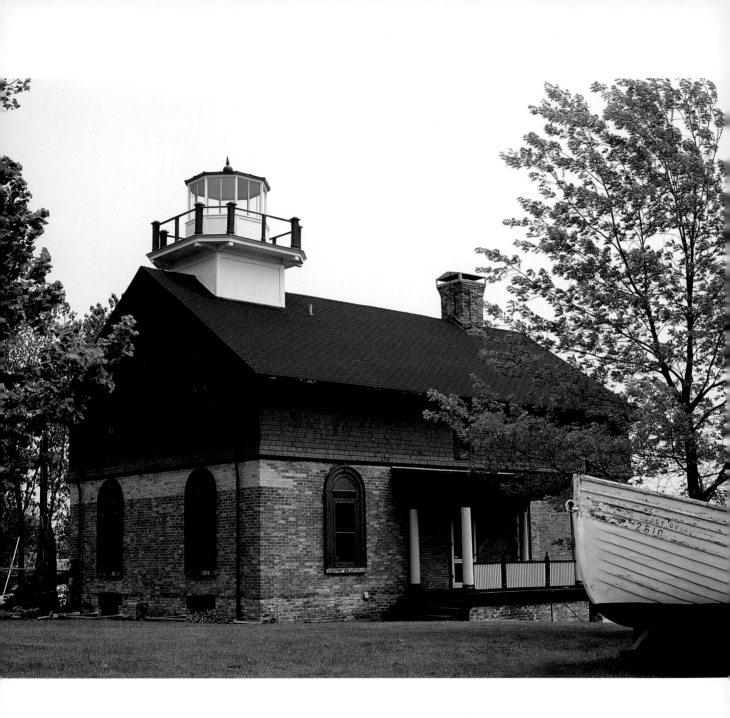

Old Michigan City

INDIANA

Michigan City, located 60 miles (97 km) east of Chicago on Lake Michigan's southeast shore, has had many lights mark its port. In 1835 Isaac C. Elston, a visionary and founder of Michigan City, deeded to the United States government a tract of land from the bend of Trail Creek to the lake for the purpose of building a lighthouse. The first light was a lantern hung on a tall post.

In 1837 Jeremy Hixon and his son were contracted by the government to build a lighthouse and keeper's dwelling. The 40-foot (12 m) conical tower had walls 3 feet (.9 m) thick and was separate from the lightkeeper's dwelling. This lighthouse's exterior eroded quickly due to the sand blown from a nearby sand dune across the river. In 1859 the government replaced it with a bigger, sturdier lighthouse. Joliet stone (a type of granite) was used for the foundation and Milwaukee brick was used for the rest of the structure. The government added a brighter fifth-order Fresnel lens with a visibility of 15 miles (24 km).

One unique keeper was a woman. In 1861 Miss Harriet Colfax, a music teacher, petitioned her cousin, Schuyler Colfax, an influential politician who eventually became U. S. Vice-President under Ulysses S. Grant, for the position of lightkeeper. Her detailed and organized logbooks are on display in the National Archives.

In 1871 a second light was added at the end of the east pier. It was built to double as a fog signal. A catwalk, now a historic structure, was built to assist the keeper in getting there during inclement weather. In her logbooks, Harriet frequently referred to risking her life and the effort that it took to crawl out on this 1,100-foot (335 m) catwalk in hurricane-force winds and waves, and the cold that congealed the lard oil fuel, which required a second trip to reheat. So diligently did Miss Colfax and her assistants perform their tasks that the Michigan City lighthouse became known on the Great Lakes as Old Faithful. Harriet retired in 1904 at the age of eighty. She died within five months of retiring.

In 1940 the lighthouse was automated and the station unmanned. It sat empty from 1940 until 1965, storm damaged and vandalized. In 1960 the Coast Guard declared the old lighthouse as government surplus, and in 1963 the City of Michigan purchased it for historical purposes. In 1965 the Michigan City Historical Society leased the building with the agreement to restore it and establish a museum. On November 5,1974, the Old Michigan City lighthouse was placed on the National Register of Historic Places.

Grosse Point

ILLINOIS

G rosse Point is a spit of land at Evanston, Illinois. The dangerous shoals off the point are directly in the shipping lanes to Chicago. The treacherous shoals caused many shipwrecks. When the Lady Elgin, a steamer carrying 350-400 passengers, collided with the schooner Augusta and nearly 300 people lost their lives, Evanston citizens petitioned Congress to construct a lighthouse at the point. The project was delayed until after the Civil War.

By 1870 over 12,000 ships annually used the port of Chicago. In 1871 Congress appropriated $35,000 for a lighthouse at Grosse Point. The light was lit February 11, 1874. The tower and duplex dwelling were yellow brick with a red roof and trim. Built on a stone foundation on wooden piles, the tower is 113 feet high (34 m) with a focal plane 121 feet (37 m) over the lake. A hundred and forty-one stairs lead up the tower to the dodecagonal cast-iron lantern. Each side has three glass plates. The lantern has a 240-degree arc of illumination.

The reflectors and lighting apparatus for the lantern cost an additional $13,000. The lantern housed a second-order Fresnel lens, the largest type used on the Great Lakes at the time. The light was a three-wick oil lamp inside the lens. The visibility was 17 miles (27 km). Its characteristic signal was a fixed white light interrupted by a ten-second red flash every three minutes.

Because lake traffic decreased and technology led to sophisticated navigational tools, the steam fog signals were discontinued in 1932, and the United States Lighthouse Service decommissioned the light station in 1935.

In 1937 the federal government deeded the property to the City of Evanston, which then leased the area to the Northeast Park District. The district keeps the light in operation as an aid to small-craft navigation. Restoration of the lighthouse began in 1973, its centennial year. In 1975 the award-winning film *Lighthouse* focused attention on this historic site. In 1976 the lighthouse was placed on the National Register of Historic Places.

The Grosse Point lighthouse has evolved into a unique complex of cultural and recreational facilities that include the Evanston Art Center, a public beach, and a nature center.

North Point

In 1837 Milwaukee's first lighthouse was built on a 56-foot (17 m) bluff to help guide vessels into the bay. In 1855 it was replaced with a 28-foot (8.5 m) tower on the same bluff but 100 feet (30.5 m) east of the present lighthouse location. This second lighthouse was undermined by corrosion, so in the 1870s Milwaukee built a third lighthouse further inland.

This new lighthouse was made of bolted cast-iron-formed plates. The two lower levels had rectangular windows with ornate lintels extending from the tapering walls. The top windows, just under the gallery, were ornately trimmed portholes. In 1912 the lighthouse was heightened for better visibility. The iron tower from the 1870s was placed on top, making the focal plane 160 feet (49 m) above the lake. A heavy band marks where the sections meet. The architect gave the lower level the same ornate porthole-style windows as the gallery. The octagonal white tower tapers quickly from a wide base to a narrower top, where a cornice flutes out to support the octagonal gallery around the octagonal black lantern. A black dome and ventilator ball top the lantern.

The first lantern burned mineral oil. In 1868 a new lens was installed. That lens is still in use. The light source is a 25,000-candle-power lamp rotated electrically and controlled by an automatic clock. The lens focuses a 1.3-million-candlepower signal visible for 25 miles (40 km).

The keepers lived in a rambling multi-level clapboard house. Its black asphalt shingles match the black trim on the lighthouse. To prevent vandalism, its lower windows are boarded up. The lighthouse has a pretty lawn that looks like a putting green and a walking path on the waterside. Behind the chain fence is a historical plaque and a hedge. In front of the lighthouse the path diverges around an oblong flowerbed. On both the east and west sides concrete railings and bridges span the ravine and lead to the park areas.

Sherwood Point

MICHIGAN

During the winter Green Bay, Michigan, was landlocked because the northern water routes were frozen. But lower Lake Michigan waters to Chicago were usually free of ice. When the Sturgeon Bay Ship Canal was constructed, Sturgeon Bay expanded as a port and Green Bay was no longer landlocked. A lighthouse at Sherwood Point marked the western entry into Sturgeon Bay and the Sturgeon Bay Ship Canal.

Congress appropriated $12,000 for the construction of this lighthouse on March 3, 1881. In May 1883 a crew of Lighthouse Board men began clearing the land. Enough stone was blasted to build a rock foundation for the lighthouse.

The building, the only one in Door County constructed of red brick, was a 25-by-37-foot (8 x 11 m), 1 1/2-story structure with a white tower rising one more level from the lake end of the building. A square red gallery holding a decagonal white cast-iron lantern topped the 35-foot (10.5 m) tower. A red dome and ventilator ball finishes the lantern's top. Red ornamental wood braces placed under the gallery provided support.

Sherwood Point's white light alternated with a flashing red light, with visibility about 15 miles (24 km). In 1892 a malfunctioning light was replaced with a fourth-order Fresnel lens and a square wooden pyramidal fog signal was added.

In 1884 the lightkeeper's niece, Miss Minnie Hesh of Brooklyn, New York, came for a short visit after the death of her parents. She married William Cochems, who became the assistant lightkeeper and then the main lightkeeper. In 1898 the Lighthouse Board appointed Minnie assistant keeper. She retained this post until her death in 1928. Her husband memorialized her by placing a small marker northeast of the lighthouse, near the road. Her ghost, with long gray-white hair and a long white nightgown, has been reported by Coast Guard personnel and by visitors staying the night at the lighthouse, especially in the upstairs bedrooms.

From 1945 until 1983 the United States Coast Guard manned the light. The light was automated in 1983. At this time the Sherwood Point Lighthouse was the last manned lighthouse on the American side of the Great Lakes. Because the lighthouse is on Coast Guard property, it is rarely open to the public.

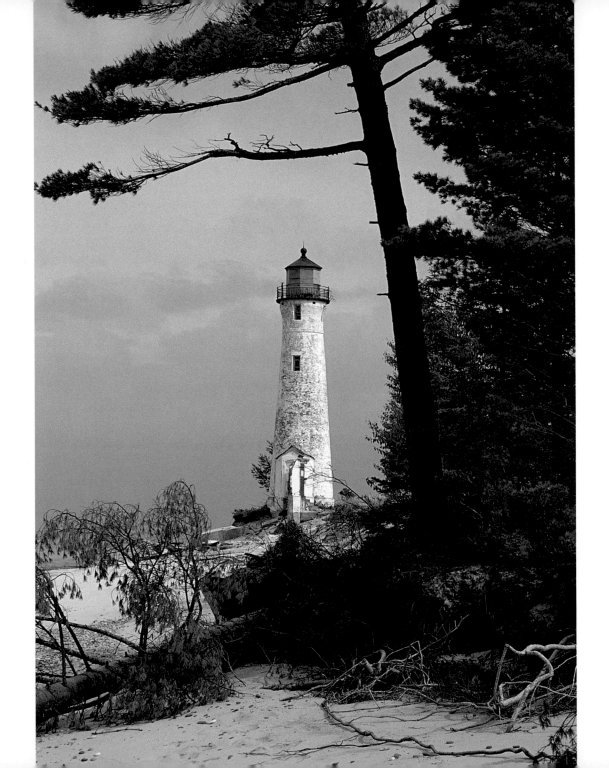

Crisp Point
MICHIGAN

One of the most remote and endangered lighthouses on the south shore of Lake Superior is Crisp Point lighthouse. Although only 13 miles (21 km) west of Whitefish Point, it remains hidden from the average traveler.

The site was operational in 1876 as the Crisp Point Lifesaving Station, built on a notorious 49-mile (79 km) stretch of Superior's shore between Whitefish Point and Grand Marais, and known as "the shipwreck coast."

The raging storms along this desolate, almost inaccessible shoreline claimed many vessels and their passengers and crew. Fierce northwest storms and violently strong currents and undertows perpetually rearrange the dangerous and deceptive sandbars.

Trained crews from the lifesaving station regularly patrolled the beaches between stations to watch for ships in distress or retrieve washed-up bodies before the wolves got them. After identification, bodies were often buried near the station because of the station's isolated location. One cemetery was located in front of the Crisp Point lighthouse. The site was maintained by keeper Joseph Singleton until "the worst storm in over one hundred years hit the shore, took that flagpole, a big pine tree, a tall pump and those graves all back into the lake."

In 1896 the Lighthouse Board recommended that a light be built at Crisp Point. In June 1902 Congress appropriated $18,000 to build the lighthouse that went into service on March 5, 1904.

Life at the isolated station was not easy. During the navigational season a number of people resided here, including the keeper, his two assistants, and the lifesaving crew of nine (later reduced to seven). In the winter, only the keeper, the lifesaving captain and their families remained. Even the soil for the garden was brought in. Natural refrigeration was supplied in the form of permafrost only a few inches below the ground surface.

In 1965, after years of vandalism to the lighthouse, the Coast Guard destroyed all buildings except the tower and a small service building attached to the base.

On July 22, 1997, the Crisp Point lighthouse was transferred to Luce County as an historical monument. The Luce County Board of Commissioners plans to lease the lighthouse to the Crisp Point Light Historical Society, who hope renovation will save the property. Storms, erosion, and vandalism have made Crisp Point the most endangered lighthouse in America according to *Lighthouse Digest Magazine* in January 1997.

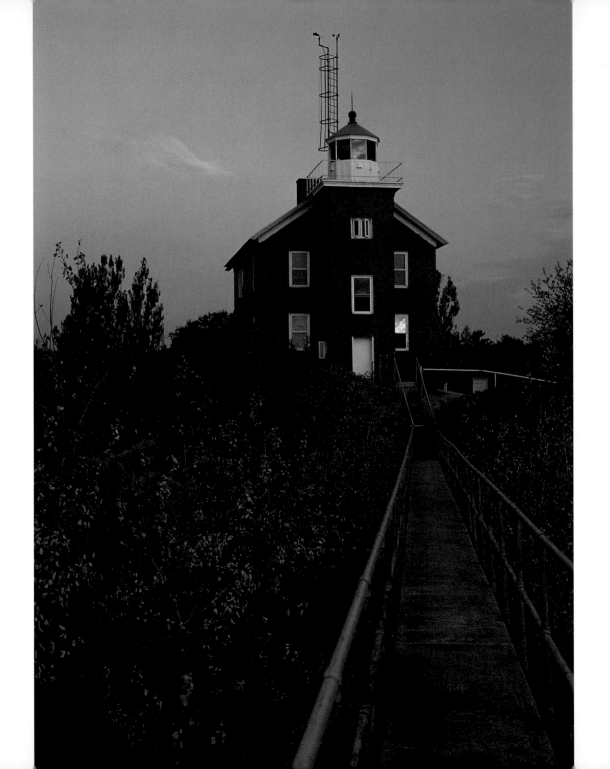

Marquette Harbor

MICHIGAN

Marquette Harbor, once known as Iron Bay, is a natural harbor along the southern shore of Lake Superior. It became a shipping center in the mid-1800s after the Marquette Range iron deposits were discovered. The first lighthouse, built in 1853 or 1855 at a cost of $13,000, was made of wood and located on a rocky point of land since known as Lighthouse Point.

A new lighthouse, built in 1866, was a one-and-a-half-story dwelling with a center front light tower designed by the United States Army Engineers. The same plans were used for lighthouses such as Grand Island North, Granite Island, Huron Island, Gull Rock, Copper Harbor and Ontonagon. Built between 1866 and 1868, these lighthouses had in common "the schoolhouse style."

The foundation was blasted from solid rock. The stone foundation, with its 20-inch-thick (51 cm) walls, was only large enough for a water-storage cistern and a fruit cellar. The outside walls of the cellar had an air space or cavity to keep the cellar's contents from freezing. The brick walls of the house were a foot thick. The first floor had one small bedroom for the keeper and his wife, a kitchen, an oil room and a woodshed at the back of the surface cellar. The cistern under the woodshed collected rainwater from the gutters for wash water. Drinking water was supplied from the lake until 1894, when town water became available.

Forty-two iron steps and four landings spiral up to the white iron decagonal lantern topped by a red dome and a ventilator ball. The back four panels of the lantern are blacked out, and five brass ventilators in the lantern increase or decrease the air flow. A fourth-order lens with a kerosene lamp produced a light with a visibility of 16 to 19 miles (26 to 31 km). In 1870 the 180-degree arc of illumination was deemed too small, so it was increased to 270-degrees.

In November 1886 a fierce three-day storm ravaged the lake. It severely damaged the fog signal building, the tower, and the catwalk. In 1888 the steamer *Arizona*, on fire and carrying barrels of acid, collided with the breakwater. The crew safely escaped onto the breakwater, and a tug pulled the vessel back out into the harbor, where it burned to the waterline. Over the years many vessels have floundered in the area. In 1911 the steamer *D. Leuty* went aground on Halloween Eve on a rocky reef directly offshore from Marquette's lighthouse during a snowstorm.

In 1939 the United States Coast Guard took over the lighthouse from the United States Lighthouse Service. During World War Two, the Marquette Coast Guard Station became a training station for about 300 recruits. In 1965 $40,000 was budgeted to refurbish the lighthouse, and in 1994 it was placed on the National Register of Historic Places. Marquette lighthouse is still operational today, using a plastic airport-type beacon light.

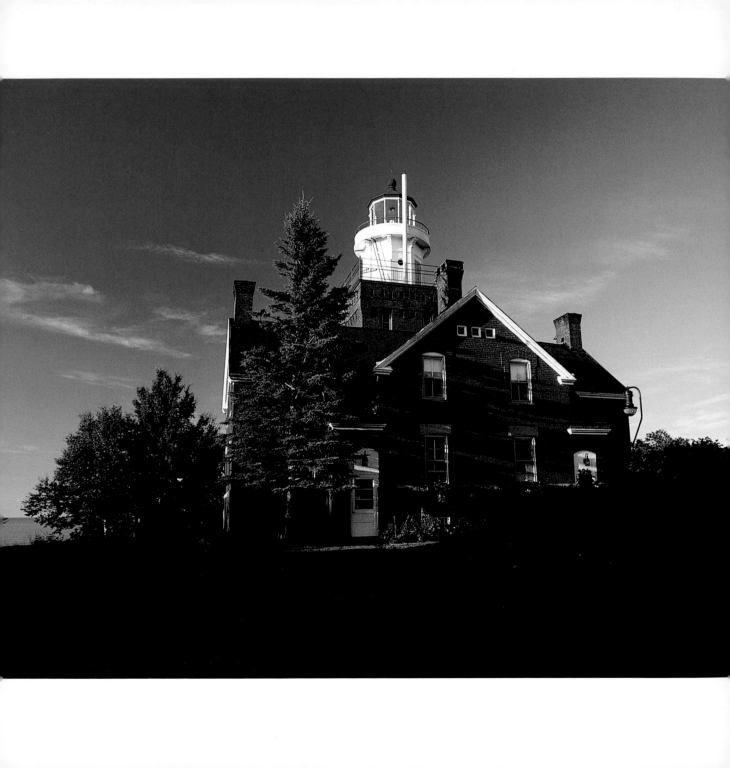

Big Bay Point

Big Bay Point has the only operational lighthouse with a bed-and-breakfast, a resident red-haired ghost, and a celebrated murder that inspired a bestselling novel and a famous movie. The lighthouse was built on a high cliff above Lake Superior in 1896 for $25,000. Located halfway between Granite and Huron Islands, the light made ship travel safer between Marquette and the Keweenaw peninsula.

The first keeper, William Prior, was a workaholic and frequently complained of lazy assistants until his son Edward took the job. When Edward died of an unattended leg injury William became despondent. One day in 1901 he left the house with a rifle and some strychnine and went into the woods. He returned that day, but soon disappeared again, not to be seen until seventeen months later when a hunter discovered a red-haired corpse in a keeper's uniform hanging from a tree just over a mile from the lighthouse. Was it suicide or murder?

In 1944 the light was automated and placed on a metal pole. In 1951 the United States Army used the assistant's house during the training of an anti-aircraft battalion. An army officer in that unit murdered the owner of the Lumberjack Tavern. This event inspired the novel, and then the movie, *Anatomy of a Murder.*

In 1961 the Coast Guard offered the lighthouse for sale to the highest bidder. Dr. John Pick, a plastic surgeon from Chicago, bought the lighthouse and its land for $40,000. After sitting vacant for many years, the lighthouse was rewired, refurbished, and refurnished with antiques.

In 1979 Dan Hitchens of Traverse City turned it into a conference retreat area. Hitchens moved the Fresnel lens to Traverse City, where it was displayed at his Park Place Motor Inn.

In 1986 the lighthouse was sold to Norman "Buck" Gotschall and two business partners, who turned it into a bed-and-breakfast; it was added to the National Register of Historic Places; and the automatic light was returned to the tower.

In 1992 the present owners, John Gale and Linda and Jeff Gamble, bought the popular lighthouse to continue renovations and develop it as a bed-and-breakfast (always booked well in advance). Linda is reluctant to talk about their resident ghost, but doors are said to bang in the middle of the night, and the red-haired ghost of Will Prior has been seen in mirrors.

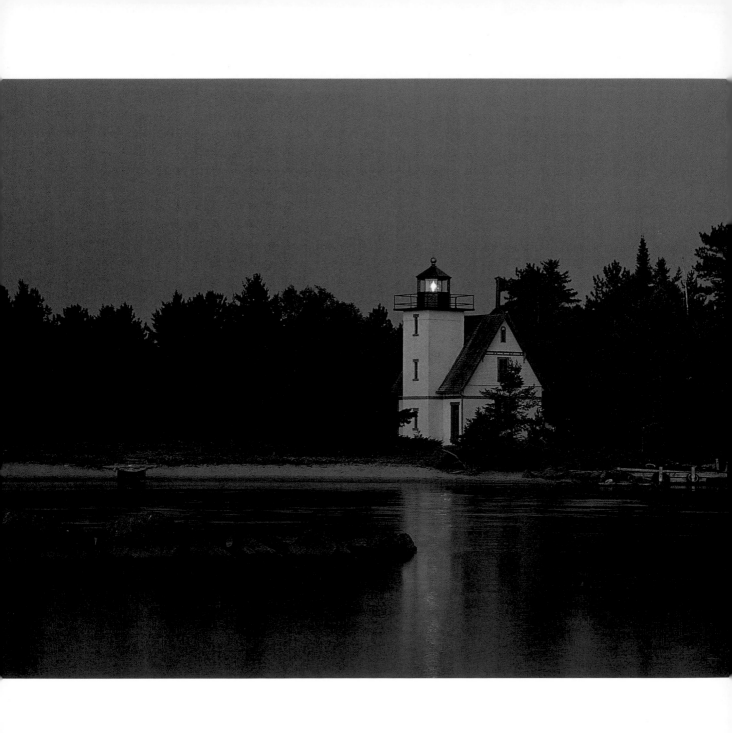

Mendota

MICHIGAN

The Mendota lighthouse is part of the Keweenaw peninsula, where copper is mined. In the mid-1800s the Mendota Mining Company mined Mount Bohemia behind Lac La Belle. To ship copper ingots to Detroit and Chicago for processing, the company cut a canal through the Bete Grise beach into Lac La Belle. In 1867 Congress approved $14,000 for the construction of a small lighthouse on the pier. By 1870 this pier light was considered too low, so it was dismantled and moved to the Marquette breakwater.

In 1892 the Lighthouse Board made a recommendation that a light be placed near the head of the bay to guide vessels to safe anchorage after dark. In 1893 the Board authorized $7,500 for the new lighthouse. The station, including light, keeper's house, boathouse, oil house, outhouse and sidewalks, was lit on November 25, 1895. It used an open flame that burned whale oil. A fourth-order lens produced a fixed white light, varied by a white flash every forty-five seconds, with a visibility of 13 3/4 miles (22 km). In 1896 its characteristic was changed to a fixed white light.

The first keeper was William G. Jilbert, who earned $500 per annum and, despite eight children, often complained in his logbook of loneliness. The lighthouse was inaccessible except by water. The tender *Amaranth* brought in supplies. In 1920 the *Amaranth* sank offshore. Coal from this ship still washes up onto the beach.

About 1913 the light was converted to electricity, using a 32-volt storage battery and a 100-watt bulb. In 1933 a new asbestos-shingled roof was put on the keeper's house and the light was unmanned and automated, using acetylene as fuel. The light was decommissioned in 1956 when two breakwater walls with lights were built into the lake at the canal's entrance.

In 1997 Gary Kohs began to restore the lighthouse. Over 30,000 visitors came on the Fourth of July weekend in 1998 to watch the relighting of the light. As curiosity, the flag on a replica pole is the Stars and Stripes of 1895, with forty-four stars. The lighthouse has a website (www.mendotalighthouse.com) that provides a brief history, and current and historical weather reports.

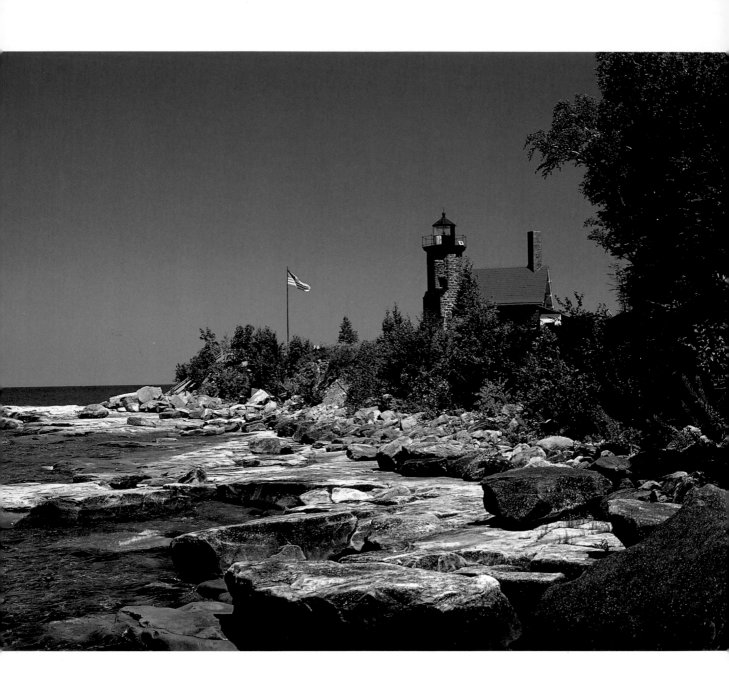

Sand Island

WISCONSIN

B y the late 1800s mariners complained that the light on Raspberry Island was insufficient to mark the western passage through the Apostle Islands, which connected shipping ports between Sault Ste. Marie, Ontario, and Wisconsin. In response, a lighthouse was built on Sand Island in 1881, as cheaply as possible, with materials found on the island. The $18,000 structure, built in a Norman Gothic style associated with churches and townhouses of the period, is made of island brownstone and is most unique in style from the other Apostle lights.

The 44-foot (13.5 m) tower built into the northwest corner of the house has a square base that turns into an octagonal top. The tower's corners have a unique "wavy" stonework pattern. Fifty-eight steps lead to its decagonal lantern, the back two panels of which are solid-steel plates. It housed a fourth-order Fresnel lens that produced a fixed white light with a visibility up to 20 miles (32 km).

In 1921 an acetylene light operated by an automated clock was installed, and the keeper from Raspberry Island checked on the light. From 1933 to 1980 the light was on a steel tower in front of the lighthouse. Then, in 1980, the tower was removed and the light was returned to the original tower.

The attached keeper's house, also brownstone, has a red pressed pattern roof, black trim, green shutters, ornamental stonework above the windows, white ornamental trim under the eaves near the lower edges, and a wooden brace and finial in the peaks.

The first keeper, Charles Lederle (1881-1891), helped build the lighthouse. In 1885 he saw the *Prussia* on fire during a storm and rowed out 10 miles (16 km) to help survivors to safety. The second and last keeper, Emmanuel Luick (1892-1921), witnessed the sinking of the *Sevona* with the loss of all seven crew on the Sand Island shoal during a terrible September storm in 1905.

Today the lighthouse may be visited by anchoring offshore, kayaking in, or landing at the dock on the south side of the island and hiking an easy 2 miles (3.2 km) on boardwalks across the island to the lighthouse.

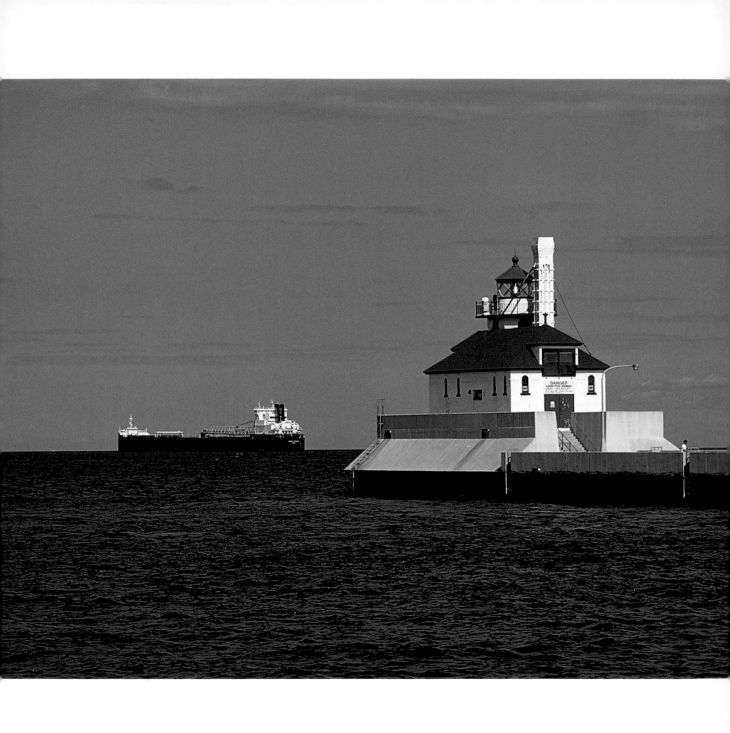

Duluth Harbor

MINNESOTA

During the 1850s hundreds of people moving to the twin ports of Duluth and Superior sought a fortune from the area's rich copper ore deposits. The natural harbors for the ports, both within Superior Bay, were protected by two long, narrow spits of land, Wisconsin Point on the south and Minnesota Point on the north. Superior Entry, a narrow, shallow natural channel between the two, led into the harbors. After the Sault locks opened in 1855, shipping of grain, coal, iron ore, and lumber increased steadily on Lake Superior, and Duluth and Superior became busier harbors.

The federal government built a lighthouse on Minnesota Point in 1858 to mark Superior Entry. Between 1870 and 1872 a shortcut called the Duluth Ship Canal was privately excavated, enabling vessels to enter Superior Bay at Duluth. The harbor was also dredged. Congress appropriated $10, 000 in 1870 for a lighthouse on the south breakwater to mark entrance from Lake Superior to the new canal.

A tower was built at the end of the pier, and the keeper's house was to be built onshore. Expansion increased, and in 1896 Congress combined the Duluth and Superior ports and for the first time provided a joint appropriation of $3 million for harbor improvements. The improvements included deeper anchorage and a dredged channel. In 1901 the Duluth pier was extended and the present Duluth Harbor South Breakwater Outer Light was built.

In 1908 the Lighthouse Board deemed the approach to Duluth Harbor to be one of the worst and most dangerous on the whole chain of the Great Lakes. To help rectify this situation a new conical tower was built on the North Pier for Duluth Harbor. It was completed in 1910 at a cost of $4,000. Now two lights mark the narrow 300-foot (91 m) channel entrance, making entry into Duluth Harbor much safer.

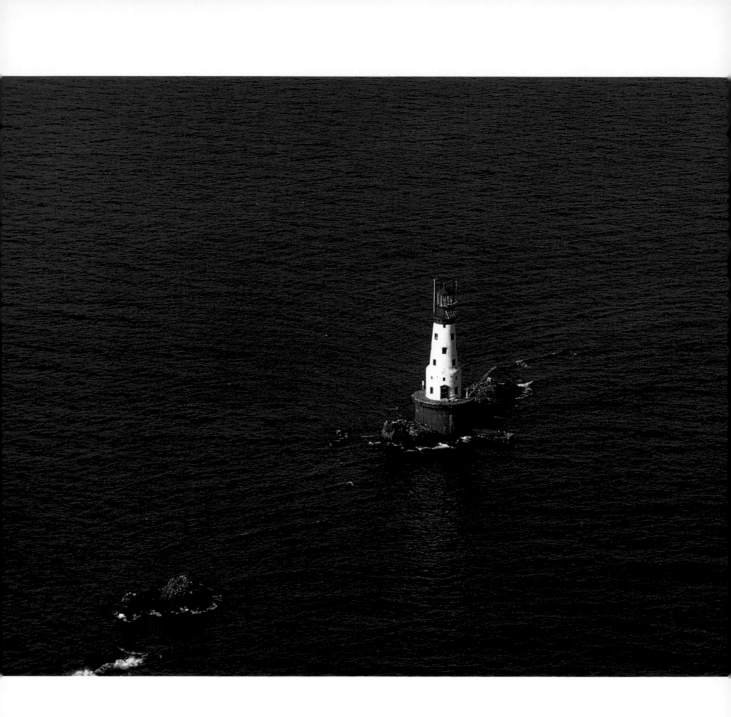

Rock of Ages

MICHIGAN

Sometimes referred to as the Jewel of the Great Lakes, Isle Royal is an archipelago of over two hundred islands and jutting rock formations in Lake Superior that have long proven hazardous to shipping. The archipelago lies approximately 50 miles (80 km) northwest of the Keweenaw peninsula, but its northern tip is only 15 miles (24 km) from the Canadian shore. The largest island is about 50 miles (80 km) long and 4 miles (6.5 km) to 9 miles (14.5 km) wide. Early French Jesuit missionaries named it Isle Royale in honor of King Louis XIV.

Pressure was put on Congress to build a lighthouse on the west side of Isle Royale in the late 1880s because the north channel above Isle Royale provided protection for ships traveling between Superior/Duluth and Fort William/Port Arthur. The initial request was for $50,000 to build a lighthouse on the Rock of Ages Island. An offshore reef sank the Canadian side-wheel steamer *Cumberland* in 1877 and the *Henry Chisholm* in 1898. By the time the latter shipwreck occurred, connstruction costs had risen to over $125,000.

The Rock of Ages light was first lit on October 22, 1908. Its temporary third-order lens displayed a fixed red light. In 1909 Congress appropriated money for a permanent lens. This second-order Fresnel lens came from France. It produced a white light visible for over 20 miles (32 km), showing a double flash every ten seconds. Because of its brilliance and speed, it was nicknamed "lightning light." Due to the lighthouse's isolation, the keeper doubled up on equipment such as transmitters, generators, diesel air compressors, and supplies.

Despite precautions, two other ships sank on the Rock of Ages reef. The steamer *North Queen* grounded on the reef in 1913. The passenger steamer *Cox* struck the reef on May 27, 1933. The lightkeepers managed to save the passengers and crew before the ship sank. Because of the shipwrecks, the site is now popular with scuba divers.

With only the sound of waves and gulls, life on "The Rock," as the Coast Guard called it, was monotonous. In 1932, after being denied shore leave for five months, keeper Melvin Whipple wrote a letter from Rock of Ages in which he described living in the round rooms as "like living in a brick stove pipe." A keeper in the 1940s, John Tregembo, referred to the light as a "spark plug" because of its shape. Most postings were four to six weeks long, with a one-day shore leave for every two weeks at the lighthouse.

The light was automated in 1978. In 1985 the Fresnel lens and clockworks were removed and put on display in the Windigo Visitors Center five miles away on Isle Royale. The light was replaced with an airport-type beacon that runs on solar power.

Today Isle Royale is a National Park, but the Rock of Ages lighthouse, still owned by the United States Coast Guard, is closed to the public.

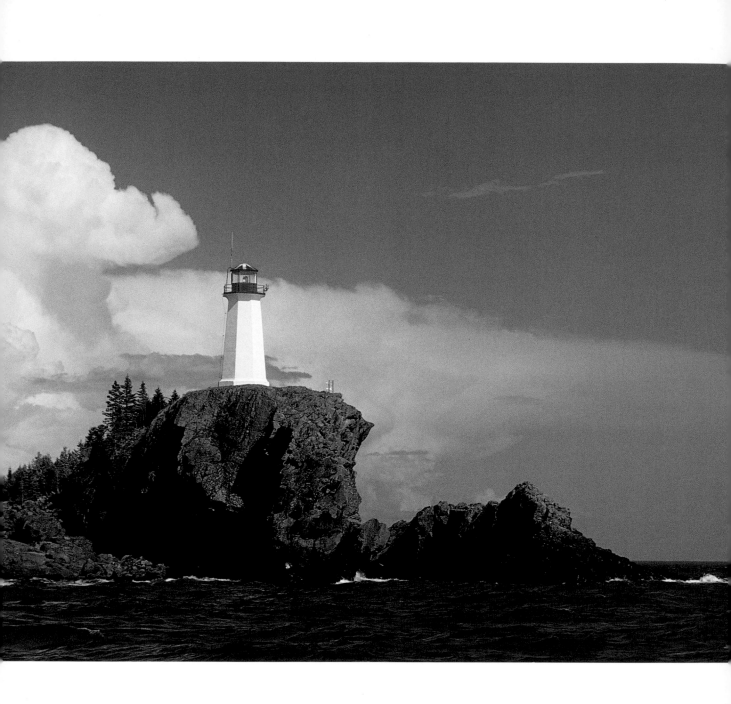

Battle Island

ONTARIO

During the Riel Rebellion in Western Canada, troops had to be brought from Eastern Canada. Since the railroad was incomplete, many troops were marched across the ice from Jackfish to the Rossport area. On this march the soldiers claimed a battle with local Ojibway. Though never documented, the incident was recalled at Battle Island when its first lighthouse was built in 1877 as the most northern lighthouse on the Great Lakes.

Battle Island is located about 7 miles (11 km) from Rossport, between Simpson Island and Wilson Island. The lighthouse was built on a 60-foot (18 m) rock face at the west end of Battle Island, close to the east-west shipping channels and the adjacent Simpson Channel at the eastern entrance to Nipigon Bay.

Built in 1911, the present tower is a white octagonal reinforced-concrete structure 43 feet (13 m) tall and is situated 117 feet (36 m) above the water. The light can be seen for 13 miles (21 km). In 1914 oil tanks were installed for a planned fog building. In 1915 the fog building and a double keeper's house were built. Over the years, the Coast Guard made necessary repairs to the house and tower.

The first official keeper, Charles McKay, stayed thirty-six years at Battle Island. He received a medal from King George V for his years of dedicated service. An excellent sailor, he often traveled to Thunder Bay or Sault Ste. Marie in a sailboat, even in the worst of frigid December weather. His fish chowder and Sunday sing-alongs were famous with summer visitors.

Other keepers at Battle Island included Edward McKay (1913-1922); Malcolm Sutherland (1922-1932), who drowned and his wife finished out the season; George Brady (1948-1967); and John Joiner (1967-1991). The last lightkeeper, Bert Saasto, was so dedicated he remained as caretaker even after the light was automated.

Williard Hubelit was an assistant keeper at Battle Island from 1960 to 1982. He received $200 a month but had to pay the chief lightkeeper $50 per month for board. His twelve-hour shift ran from midnight until noon. He remembers coal-oil lamps and air mantels so sensitive that one drop of condensation or a single moth flying into the mantel could break it.

The name Battle Island could also refer to fierce storms that sank ships and injured keepers. In 1971 Hubelit lost part of a finger when mountainous waves washed over the lighthouse and slammed a door on his hand. In 1977 the winds during a three-day storm were clocked at 80 mph (130 km). Waves estimated at over 100 feet high (30 m) crashed over the tower.

In 1991 Battle Island was automated and became the last unmanned lighthouse on the Great Lakes.

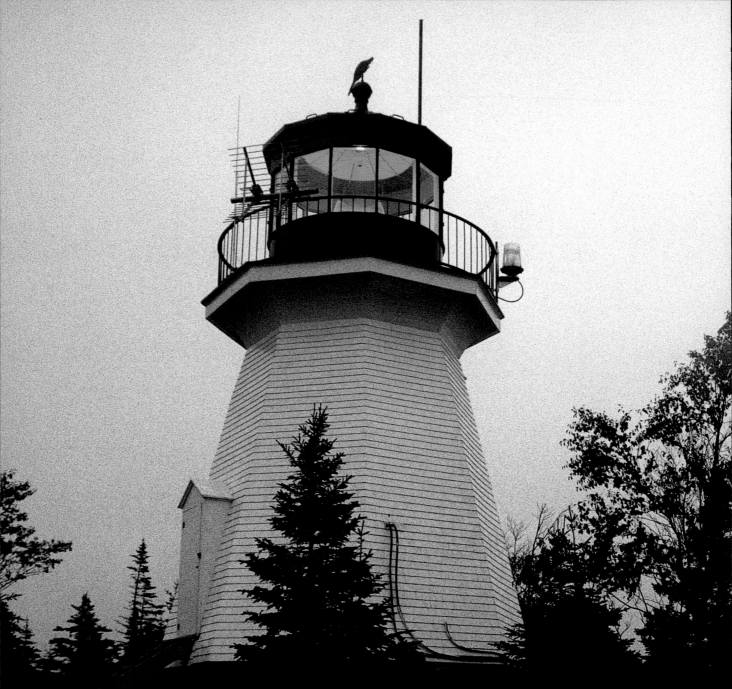

Slate Islands

ONTARIO

The Slate Islands are a group of eight major islands 8 miles (13 km) from Terrace Bay, Ontario, in Lake Superior. A meteor may have formed the islands, which boast unique arctic vegetation. Terrace Bay is about 160 miles (256 km) due north of Marquette, Michigan, at the widest part of Lake Superior.

In 1902 the Slate Island lighthouse was built on 29.6 acres (12 ha) of land on Patterson Island's southeast side, Sunday Point. The short lighthouse, sitting on a cliff about 250 feet (76 m) above the lake, is in fact the highest light on Lake Superior. The location of the keeper's house at the base of Sunday Bay meant a long, steep, and sometimes dangerous climb to the light. The Slate Island lighthouse and the Battle Island lighthouse marked the entrance to Nipigon Bay.

No one kept an exact list of lighthouse keepers at Slate Island. Peter King, a gambler and frustrated fortune hunter, was the first keeper. The next, Charlie Lockwood, died while at the light. His wife kept his body on ice in the back shed until he could be buried properly on the mainland.

In 1948 Jack Bryson was appointed lightkeeper. He kept the light for thirty years until his retirement in 1978. The Bryson family can recount anecdotes concerning ice storms so fierce that the ice had to be chopped off the doors of Coast Guard ships, and visits from albino caribou, French oceanographer Jacques Costeau, and the ghost of Charlie Lockwood.

In 1989 the last official keeper, Orten Rumley, was removed and the lighthouse was unmanned. At this time the last operational pneumatic foghorn system on the Great Lakes was dismantled from the Slate Island lighthouse and donated to the Neys Provincial Park. The lightkeeper's logbooks were also donated to the park. The clockworks remain in the tower. The light's visibility is an average of 20 miles (32 km), though it has been reportedly seen from Superior Shoal, some 30 miles (48 km) away.

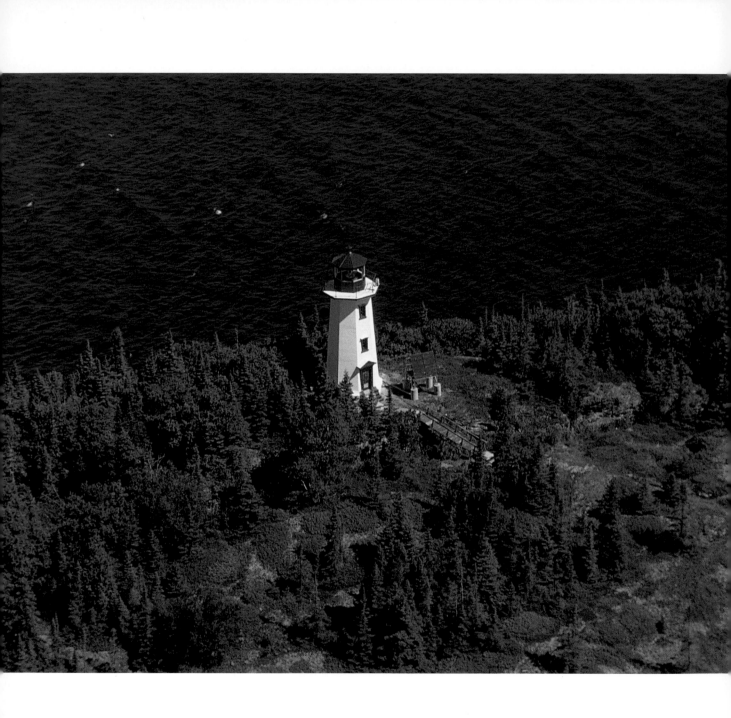

Davieaux Island

ONTARIO

Michipicoten Island is a volcanic island 30 miles (48 km) southwest of Michipicoten Harbor in Lake Superior. In native dialect, Michipicoten Island means "the floating island" and received its name because fogs seem to change the shape of the islands. The natives also warned travelers of a mysterious sickness caused by spirits on the island. This was later found to be copper poisoning. Later mariners called Michipicoten "the gem of Lake Superior" because of its unique vistas and the agates found on its beaches.

A copper mine was built in the nineteenth century, and the ore was moved over a manmade road to Quebec Harbor, a large natural harbor on the island's south side. A port and docks accommodated boats that shipped the ore for processing. The first lighthouses for the harbor were built in 1872. One was built on Chimney Point, on the east side of the harbor's entrance. The other was established on Agate Island, a small island just inside the entrance to Quebec Harbor. Hyacinthe Davieaux manned both of these lights until he died at the island lighthouse in 1910. His son Charles took over the position.

In 1917 the Lighthouse Board moved the Agate Island lighthouse to the north shore of the harbor, where it worked with newly built rear lights to guide ships safely into the harbor. The lighthouse at Chimney Point was moved to Long Island, in front of the harbor, as an interim tower until the completion of a new octagonal reinforced-concrete lighthouse (now painted red and white).

Keeper Charles Davieaux and his wife lived at the range station and raised six children. Charles rowed across the bay each evening to the lighthouse, where he spent the night. About midnight, he trimmed the wicks, checked the fuel and wound the weights. He was keeper until he died at the age of eighty-four in 1933. Long Island, the main island guarding the harbor entrance, was renamed Davieaux Island in his memory. In 1938 the government built a proper house at the ranges.

In 1965 a new electric foghorn replaced the 1928 model. Its pattern was a three-second blast followed by silence for three seconds, then another three-second blast, followed by fifty-one seconds of silence.

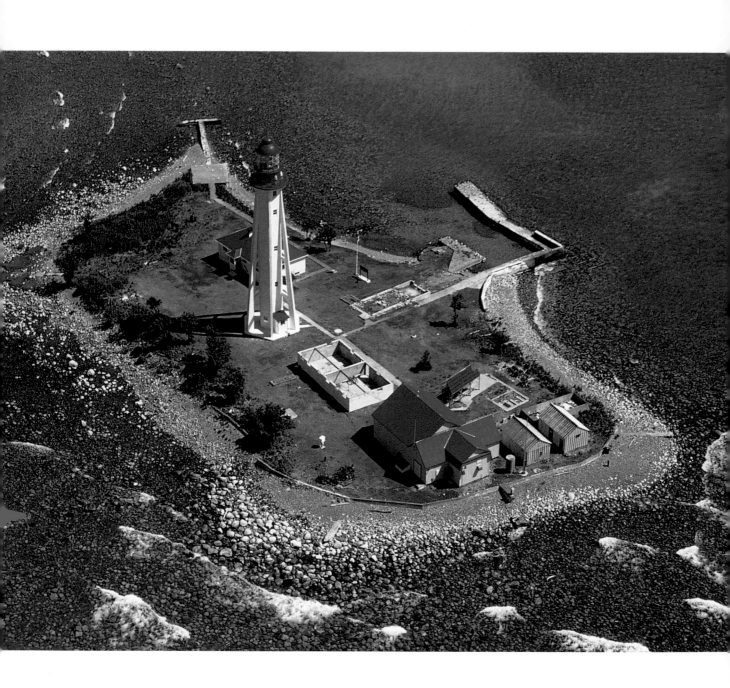

Caribou Island

ONTARIO

Some say lonely Caribou Island was named after Americans bought the island and stocked it with caribou. Located in Lake Superior, it is one of the most isolated islands in all the Great Lakes. It is situated 55 miles (88 km) offshore from the mainland, 90 miles (144 km) from Sault Ste. Marie, 65 miles (104 km) southwest of Michipicoten Harbor, and about midway between Canada and the United States. Weather here can be fierce, with storm winds over 70 mph (113 km) and waves up to 20 feet (6 m). Early natives believed that a giant snake guarded a cache of gold on this island. And to this day, mariners claim the ghostly lights of wrecked ships can still be seen.

The Caribou Island lighthouse is on a small island a short distance southwest of the main island. The dangerous Caribou shoals, some still uncharted, stretch fingerlike through the surrounding waters.

The first light was built here in 1886, but it was replaced in 1912 with the lighthouse we see today. This second lighthouse was an example of a new state-of-the-art architecture using a reinforced-concrete, flying buttress style designed by Lieutenant Colonel William P. Anderson, Chief Engineer for the Canadian Department of Marine and Fisheries. The design is based on Gothic cathedral elements, and in this case the structure is centered on a concrete hexagonal tower rising from a round concrete base. The reinforced concrete helps to stabilize the 82-foot (25 m) tower in strong winds, preventing vibration so that he lantern will function at optimum accuracy.

Keepers for Caribou Island had to be both hardy and resourceful. The first keeper of the light, George Johnston (1912-1921), fashioned a rifle from a pipe to shoot rabbits.

In 1915, as a cost-cutting measure, the Canadian government stopped providing transportation to and from lighthouses. Another keeper and his assistant spent a week sailing a 30-foot (9 m) sailboat with a sea anchor 65 miles (105 km) to the mainland in an ice storm at the close of the season. A government boat was finally provided for lighthouse keepers. But the government boat CGS *Lambton* sank in a storm in 1922, just 15 miles (24 km) east of Caribou Island. Many say its ghostly shape can still be seen.

BIBLIOGRAPHY

Bailey, C. "The Forgotten Beacon." *The Great Lakes Pilot*, 3,6. Grand Marais: Great Lakes Pilot Publication 1997.

Barret, H. *Lore and Legends of Long Point*. Don Mills: Burns and MacEachern, 1977.

Benghuuser, B. "Sturgeon Point History Reported." *The Beacon*, volume 10, number 2, Allen Park:
 Great Lakes Lighthouse Keepers Association,1992.

Biggs, J. "A Birds Nest." *The Beacon*, volume 11, number 2. Allen Park: Great Lakes Lighthouse Keepers Association.

Buscombe, D. "Port Rowan and Long Point Scenes of Change and Charm." Port Dover, 1975.

Cabot Head Historical Information. "Cabot Head Lighthouse." Cabot Head, 1998.

Charlotte-Genesee Lighthouse Society. "Enlightening The Past Beacon for the Future." Rochester:
 Charlotte-Genesee Lighthouse Society, 1998.

Chisholm, Barbara. *Superior Under the Shadow of The Gods*. Lynx Images, 1998.

Edwards, J. Round Island Lighthouse Great Lakes Cruise, volume 3, issue 5. Royal Oak: Great Lakes Cruiser Ltd., 1996.

Evanston Historical Society. Historical Summary of Grosse Point Lighthouse. Evanston: Evanston Historical Society, 1998.

Feret, L. "The North Shore to Duluth." *The Beacon*, volume 15, number 2. Allen Park: Great Lakes Lighthouse Keepers Association, 1997.

Gamble, Linda. *A Keeper's Log*. Chattanooga: Keepsake Enterprises Ltd., 1998.

Gutshe, A. *Alone in the Night*. Toronto: Lynx Images Inc., 1996.

Hill, R. "Life on Crossover Island." *The Beacon*, volume 7, number 4. Allen Park: Great lakes Lighthouse Keepers Association, 1989.

Jenvey, B. Michigan City, "Off-Shore in Indiana," *Great Lakes Cruiser*, volume 3, number 5. Royal Oak: Great Lakes Cruiser Ltd., 1996.

Karges, Steve. Sherwood Point Light. Door County Maritime Museum Information, 1998.

Lyall, C. *Simcoe Island, An Eves Perspective*. Cobourg: Haynes Printing Co., 1994.

Marquette Marine Museum. "Marquette Lighthouse." Marquette: Marquette Marine Museum, 1998.

Metcalfe, W. *Canvas and Steam on Quinte Waters*. Picton: Prince Edward Printing, 1993.

Nelson, B. "Ludington North Breakwater Light." Ludington: Mason County Historical Society, 1998.

Nelson, B. Renovation of the Ludington North Breakwater Light. *The Beacon*, volume 11, number 2. Allen Park:
 Great Lakes Lighthouse Keepers Association, 1993.

Nelson, B. "Crisp Point Lighthouse and the Storm Warriors." *The Beacon*, volume 9, number 3. Allen Park:
 Great Lakes Lighthouse Keepers Association, 1991.

Old Lighthouse Museum. "The Old Lighthouse." Michigan City: Old Lighthouse Museum, 1998.

Penrose, L. *A Travel Guide to 100 Eastern Great Lakes Lighthouses*. Davison: Friede Publishing, 1994.

Penrose, L. *A Travel Guide to 116 Lighthouses of the Western Great Lakes*. Davison: Friede Publishing, 1995.

Penrose, L. *A Travel Guide to 116 Michigan Lighthouses*. Davison: Friede Publishing, 1993.

Queen's Wharf History Information. "Queens Wharf Lighthouse," Toronto: Marine Museum of Upper Canada, 1998.

Stockton, Don. "Fairport Harbour." *Great Lakes Cruiser*, volume 2, issue 10. Royal Oak: Great Lakes Cruiser Ltd., 1995.

Stone, D. *Long Point, Last Port of Call*. Erin: Boston Mills Press, 1988.

Stone, D. *Waters of Repose*. Erie: Erie County Historical Society, 1993.

Tinney, James. *Seaway Trail*. Sacket Harbour: Seaway Trails Inc.,1989.

Tregembo, John. "Rock of Ages." *The Beacon*, volume 19, number 3. Allen Park: great Lakes Lighthouse Keepers Association, 1991.

Vogel, M. "A Look at Lorain Lighthouse." *The Beacon*, volume 9, number 1. Allen Park: Great Lakes Lighthouse Keepers Association, 1991.

Vogel, M. "40 Years Ago at Fort Gratiot." *The Beacon*, volume 6, number 3. Allen Park: Great Lakes Lighthouse Keepers Association, 1988.

Weeks-Mifflin, Marg. *The Light on Chantry Island*. Erin: Boston Mills Press.